NK
4168
.K86
S2713
1973

Sato, Masahiko,
1925–

Kyoto ceramics

146637

DATE			

146637

DATE DUE

NOV 17 1983			

Kyoto Ceramics

EDITORIAL SUPERVISION
FOR THE SERIES

Tokyo National Museum
Kyoto National Museum
Nara National Museum

with the cooperation of the
Agency for Cultural Affairs
of the Japanese Government

FOR THE ENGLISH VERSIONS

Supervising Editor
John M. Rosenfield
Department of Fine Arts, Harvard University

General Editor
Louise Allison Cort
Fogg Art Museum, Harvard University

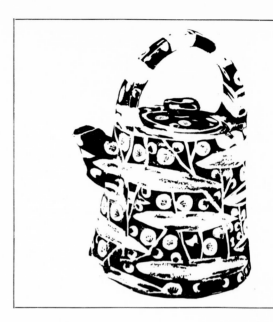

KYOTO CERAMICS

by Masahiko Satō

translated and adapted by
Anne Ono Towle *and* Usher P. Coolidge

New York · WEATHERHILL/SHIBUNDO · *Tokyo*

This book appeared originally in Japanese under the title Kyōyaki *(Kyoto Ceramics) as Volume 28 in the series Nihon no Bijutsu (Arts of Japan), published by Shibundō, Tokyo, 1968.*

The English text is based directly on the Japanese original, though some small adaptations have been made in the interest of greater clarity for the Western reader. Modern Japanese names are given in Western style (surname last), while premodern names follow the Japanese style (surname first).

First edition, 1973

Published jointly by John Weatherhill, Inc., 149 Madison Avenue, New York, N.Y. 10016, with editorial offices at 7-6-13 Roppongi, Minato-ku, Tokyo; and Shibundō, 27 Haraikata-machi, Shinjuku-ku, Tokyo. Copyright © 1968, 1973 by Shibundō; all rights reserved. Printed in Japan.

Library of Congress Cataloging in Publication Data: Satō, Masahiko, 1925–/Kyoto ceramics./(Arts of Japan, 2)/Translation of Kyōyaki, v. 28 (1968) in the series, Nihon no bijutsu./1. Pottery—Kyoto—History. I. Title./NK4168. K86S2713 1973/738' 0952'191/72-92256/ISBN 0-8348-2701-8 (hard) 0-8348-2704-2 (soft)

Contents

Translators' Preface

VERY LITTLE is known in the West about the ceramics of Kyoto except for the work of her two most famous potters, Ninsei and Kenzan. For almost a century these two men have managed to fascinate and frustrate Occidental curators, collectors, and students, while the wares of their fellow Kyoto potters, largely nameless, have been little studied and never fully appreciated. It is hoped that this translation into English and adaptation of Masahiko Satō's book on the ceramic wares of Kyoto will bring to the Western reader a feeling for the history, the perfection, and the beauty of the pottery produced in and around a city that was for many years the capital of Japan and the arbiter of the entire country's aesthetic tastes.

We have had the very good fortune of discussing various aspects of this book with the author, who was kind enough to read the English text and to make corrections wherever our translation went astray. In addition, he was extremely helpful in making the adaptations that seemed necessary if the book was to be understood by readers unfamiliar with the Japanese historical and cultural background. Needless to say, any errors or inconsistencies that have crept into the final text, despite Mr. Satō's efforts to make the English version as accurate as possible, are entirely ours.

The original glossary has been considerably modified by the omission of many Japanese technical terms and by the addition of the names of ceramic wares that might be familiar to the average Japanese reader but not to the Westerner. In adapting the glossary, as elsewhere in the book, the translators accept all responsibility for any errors that may remain.

A.O.T.
U.P.C.

An Introduction to Kyoto Ceramics

IN THEIR TRADITIONAL LITERATURE, the Japanese have always referred to the city of Kyoto simply as *kyō*—"the capital." Home of the imperial household, the aristocracy, and the court, Kyoto remained the capital of Japan from A.D. 794 until the Meiji Restoration of 1868, nominally, if not always actually, in control of the land. The ceramics produced in the city during the latter part of that period have traditionally been known as *kyōyaki* or "Kyō ware" rather than "Kyoto ware." To Japanese ears, the term Kyōyaki is more than simply an indication of the origin of a certain type of pottery: it reverberates with associations of a special courtly elegance and of the refined Kyoto culture out of which the pottery developed.

Fine ceramics are still made in Kyoto today, but the name "Kiyomizu ware" has slipped into general use in recent years because so many of the potters live on the narrow, sloping streets that lead steeply up to the Kiyomizu temple on the eastern side of the city. The Meiji Restoration, in which the imperial court was moved from Kyoto to Tokyo, makes a convenient dividing line between Kyōyaki and Kiyomizu ware. The date of 1868 is selected not because marked technical changes in pottery making occurred abruptly in that year, but rather to emphasize the fact that Kyōyaki is essentially a product of the Edo period (1603–1868), while Kiyomizu ware is a creation of the modern age. In addition, the Restoration of 1868 serves as an appropriate terminal date for Kyō ware, for it marks the end of a period in which high standards of quality prevailed; few ceramics made in Kyoto after that time equal in excellence those dating from the Edo period.

Dating the origins of Kyōyaki presents a far more difficult problem than determining its end. For the moment, it is enough to say that this type of ceramics began to be made during the Momoyama period (1568–1603). Ceramics had been produced in the Kyoto area during the Nara and Heian periods (seventh through the twelfth centuries) and some pieces have been traced back to prehistoric times. But such pieces are so remote and so totally different in style that only ceramics made in Kyoto shortly before and during the Edo period will be regarded as true examples of what is to be identified here as Kyōyaki.

Kyō ware comes in many forms: some pottery, some porcelain; some decorated with an overall monochrome glaze, others with elaborate designs in multicolor overglaze enamels. Diversity makes it difficult to point to any single common denominator to be used in identifying Kyōyaki, as would be easily possible to do in the case

of Bizen or Shino ceramics. Still, there is a quality that unites all examples of Kyōyaki, a quality that can be described only as a feeling of refinement that seems to grow out of the very environment of Kyoto itself—the natural setting of the city, its history, and its culture. Every object illustrated in this book radiates the aura of this special Kyoto refinement that is difficult to capture in words. Perhaps an examination of a single, representative piece of Kyōyaki will serve best to clarify this point.

Plate 46 illustrates a small incense box made early in the Edo period by Nonomura Ninsei, one of Kyoto's greatest potters. To make this box, Ninsei molded fine white clay into the shape of a New Year's toy and colorfully decorated it with an auspicious pattern incorporating a crane and tortoise-shell motif.

The care taken to create a shape with simple, harmonious proportions makes this box typical of Kyō ware. And yet in Japan in the early seventeenth century, concern for the perfection of form was unusual. For example, Oribe ware, which is named after the venerated tea master Furuta Oribe, is known for tea bowls that are neither round nor square nor any fixed, regular shape. They possess instead an individuality that is fascinating precisely for its irregularity and asymmetry. Owing to the growing popularity of the tea ceremony during the late Momoyama and early Edo periods, novel shapes of this kind were in great demand. Tea masters prized the unusual and the natural. To them, unfinished or distorted forms held much greater meaning than those that were mechanically perfect.

Against this background of aesthetic taste, the formal and clean lines of Ninsei's incense box must have stood out sharply. However, he was not alone in his desire for classic proportions and technical perfection. The Arita kilns in Kyūshū were producing fine blue-and-white porcelain inspired by Chinese models. But these were foreign models. Kyōyaki was the first native Japanese ware to devote special attention to perfect plastic form.

Ninsei's incense box also reveals Kyō as the first purely Japanese ware to recognize the decorative possibilities of the ceramic medium. Painted decoration on ceramics did not appear until the Momoyama period, and early examples were crude and experimental. The designs often seem improvised, unsuited to the object on which they appear, and generally meaningless. The awkwardness of this initial stage in ceramic decoration is illustrated by painted Karatsu tea bowls and by some of the Oribe and Shino tea-ceremony pieces made in the Nagoya area. In marked contrast, the decoration found on Arita porcelain is skillful and precise, but inspired by continental taste, it can hardly be considered truly Japanese.

The enamel decoration on Ninsei's box is clearly executed with a high degree of skill and care. At the same time, the various decorative elements—crane, pine and bamboo, and tortoise-shell pattern—reflect the grace and elegance of Kyoto in a manner that is quite un-Chinese. The outline of the shell pattern against the light background is not simply a straight line but is irregular and unpredictable. The effect is one of both precision and imaginative freedom. This sort of flair for subtle and original decoration is a product of Kyoto's long cultural heritage, and is to be seen in almost every piece of Kyōyaki, whether by the great Ninsei or by some nameless potter. It is a quality that distinguishes at once the ceramics of the capital from those made at provincial centers like Karatsu and Arita.

Kyoto Ceramics

1

The Origins of Kyoto Ceramics

Pottery with multicolored lead glazes, based on Chinese models of the T'ang dynasty (618–907), was made in the Kyoto region during the eighth century. It disappeared in the Heian period (794–1185), and for more than four hundred years little or no ceramics were produced in the vicinity of the capital. Not until the early Momoyama period did Kyoto's kilns resume activity with the production of a ware called Oshikōji. Few examples of Oshikōji are extant and what little is known about the ware is largely in the realm of speculation. It is thought to have been an early form of Japanese Raku ware, influenced by pottery from southern China known as Kōchi ware in Japan (Chinese: Chiao-chih). Like Raku, Oshikōji was probably fired at low temperatures and decorated in the manner of Kōchi ware with enamels of blue, green, and red

in colored designs carved in the surface of the clay. This method of decoration can be considered an adaptation to ceramics of the currently popular technique of cloisonné manufacture.

The existence of Oshikōji ware is verified by a notation in the personal writings of Ogata Kenzan (1663–1743), one of Kyoto's master potters, but its appearance is not described. It is quite possible that the identity of Oshikōji ware was lost in mistaken identification of examples of it as genuine Kōchi pieces from China or as later Kyoto copies called colored Raku.

There does exist, however, a piece that may give some idea of how Oshikōji ware actually looked. Plate 1 illustrates a small incense box in the shape of a badger made by the potter Rihei, who was trained at the Awataguchi kilns in Kyoto. It was apparently

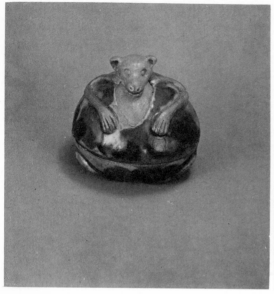

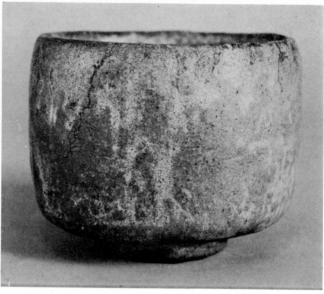

1. *Rihei: Incense box in the shape of a badger. Matsudaira Public Foundation.*

2. *Chōjirō: Red Raku tea bowl, called Jirobō.*

made around 1650, when Rihei was producing pottery for the Matsudaira family in Takamatsu on Shikoku. Although not actually produced in Kyoto, this piece cannot be overlooked in a discussion of Oshikōji ware.

The wooden storage case for the incense box is marked "copy of Kōchi ware," probably indicating that the box should show how the Kōchi style of glaze would have looked on Oshikōji ware. Blue and purple glazes are thickly applied except on the head and chest of the animal. Yet the glaze on this incense box is not an exact copy of glaze used on Kōchi ware: Kōchi was fired at rather low temperatures, while this piece was fired at a temperature sufficiently high to turn to purple a glaze that would otherwise have been green. It also seems certain that most pieces of Oshikōji ware

were small in size because the capacity of the kilns was limited and because, if the present incense box is to be taken as representative of the ware, its blue and green glazes had to be thickly applied.

Early Kyō Ware

Oshikōji ware made its appearance at the beginning of the Momoyama period, and was, apparently, an early form of Raku that employed colored glazes of the type used in southern China. By the middle of the Momoyama period, the more familiar type of Raku ware with a more restrained color scheme had come into being, and it was this type that is to be seen in so many of the famous tea bowls of the time and of the following century. The initial inspiration for this

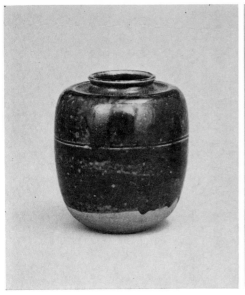

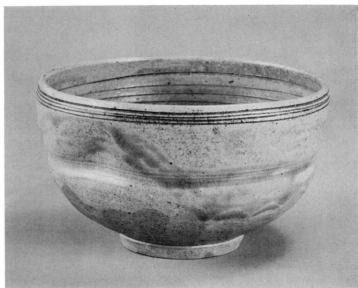

3. Ninsei: Square-shouldered tea caddy with Seto-style glaze. Nezu Art Museum, Tokyo.

4. Shūgakuin-ware tea bowl. Tekisui Art Museum, Ashiya.

shift toward a quieter, more subdued aesthetic can be attributed to the celebrated tea master Sen no Rikyū (1521–91), who supervised the potter Chōjirō in the making of bowls specifically for the tea ceremony. Rikyū may well have used Oshikōji ware as a point of departure. Certainly, the type of pottery that resulted, as seen in Plate 2, is unusual in its avoidance of self-conscious artistry. Although the Raku tea bowls of the Momoyama and Edo periods can be considered a form of Kyō ware because so many of them were made in the capital, they form a fascinating subject of specialized study, and it is customary to include them under the category of tea utensils.

It should be stressed that in Kyoto of the early seventeenth century the tea ceremony was widely practiced and utensils of all kinds were much in demand.

The tea caddy was considered a particularly important part of the ceremony, and those made in China were most highly prized. But, since imported Chinese pieces were rare and costly, it was not uncommon to have caddies made at Seto, the most active of the old Japanese ceramic centers, located some seventy-five miles to the northeast of Kyoto. Later, potters skilled in the making of tea caddies were probably brought from Seto; by the end of the Momoyama period, a kiln producing tea caddies had been established in the capital. There is no direct evidence for the existence of this kiln, but in 1605, a wealthy merchant, Kamiya Sōtan of Hakata, mentions in his tea diary for that year "square-shouldered Kyō ware," which can mean only a tea-caddy shape. Other sources indicate that the kiln producing these tea caddies may have been

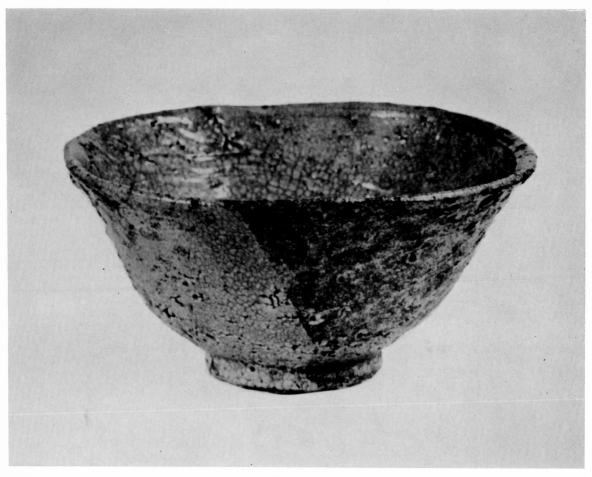

5. Korean bowl of the type called irabo, *and used as a tea bowl in Japan.*

located on land owned by the Shōren-in temple in the Awataguchi district.

These pieces made in Kyoto for the tea ceremony might be called Kyoto-style Seto ware. That they were highly prized in cultured circles is frequently mentioned by the scholarly Buddhist monk Hōrin Shōshō of the Kinkaku-ji temple in his diary entitled *Kakumei-ki.* The names of such famous potters of the day as Seibei and Sakubei appear repeatedly in the section of the diary that recounts how tea caddies were made under the supervision of the priest and tea master Kanamori Sōwa. Most of the pieces mentioned were tea containers in the Seto style with reddish iron glaze; other types included *goki* and *irabo* tea bowls, both

Japanese copies of Korean wares produced early in the Yi dynasty (1392–1910).

Unfortunately, the identity of these early pieces made at Awataguchi in Kyoto has been lost amid the multitude of later wares. Very rarely did individual pieces bear the name of the potter or his kiln, with the result that Kyoto tea caddies were often mistaken for Seto or Chinese pieces and tea bowls for Korean wares. This confusion is borne out by a comment in the *Chaki Bengyokushū,* a seventeenth-century study of earlier Edo-period tea utensils, that many counterfeit Chinese pieces were to be found among the Awataguchi caddies. These were not intentional fakes but pieces incorrectly identified by a later age.

Lacking examples, it is difficult to re-create the appearance of the earliest Kyō ware, but fortunately some clues are provided by tea containers of slightly later date that are believed to reflect closely the earlier style. One of the best of these is a caddy with a Seto glaze made by Ninsei (Plate 3). In his *densho* ("secret notes"), which was later passed on to Kenzan, Ninsei discusses in detail the glazing of Seto-style ceramics. Although Ninsei took the greatest pride in his mastery of colored enamel decoration, he was equally skilled in the making of the more subdued wares such as this piece. It does not seem unreasonable, therefore, to see in his little tea caddy a reflection of the early Seto-style Kyōyaki.

Korean-Style Tea Bowls

A similarly indirect method is necessary to re-create the appearance of Japanese copies of Korean tea bowls. Without examples of the actual bowls made by Sakubei at Awataguchi or by Seibei at the Yasaka kiln just south of Awataguchi, we must look to bowls of somewhat later date for reflections of the early Kyōyaki style. Perhaps the most reliable sources of clues to the appearance of the early tea bowls are the surviving bowls fired at the Shūgakuin and Nogami kilns in Kyoto (described in greater detail in Chapter 4). Both these kilns were active slightly later than the Awataguchi or Yasaka kilns mentioned above, but because both were under the jurisdiction of the imperial household they presumably carried on older traditions.

Plate 4 illustrates a Shūgakuin tea bowl made for Emperor Gomizuno-o, who reigned from 1611 to 1629. The emperor provided the kiln with a pattern indicating the desired profile for the tea bowl, in this case Korean in style. The resulting piece shows a well-balanced blending of Japanese and Korean features and represents clearly the style favored by Kyoto potters during the first half of the seventeenth century. It is highly probable that earlier Kyoto copies of Korean bowls looked much the same.

Plate 5 illustrates a bowl actually made in Korea, in the so-called *irabo* style. It was not intended for any such ceremonial function as a tea bowl, but rather as a simple, utilitarian rice bowl. The makers of such everyday wares of the early Yi dynasty were little concerned with technical perfection or with the quality of their materials. Economy and speed of production were their primary aims; the results, though technically unsatisfactory, often have a strong, artless charm. During the Muromachi (1336–1568) and Momoyama periods, it was just this naive and unaffected quality of the Korean bowls that caught the fancy of Japanese tea masters. But by the early seventeenth century, changing taste in the tea ceremony demanded utensils of greater sophistication and delicacy and made for the happy mixture of Japanese and Korean styles.

The earliest Kyō style of ceramics, although their identity and exact appearance are lost to us, is dimly reflected in such later pieces as the Shūgakuin bowls and Ninsei's caddy described above. Through painstaking study of the forms, glazes, and firing methods of these later pieces, we can slowly develop an idea of what the earliest Kyō ware must have looked like.

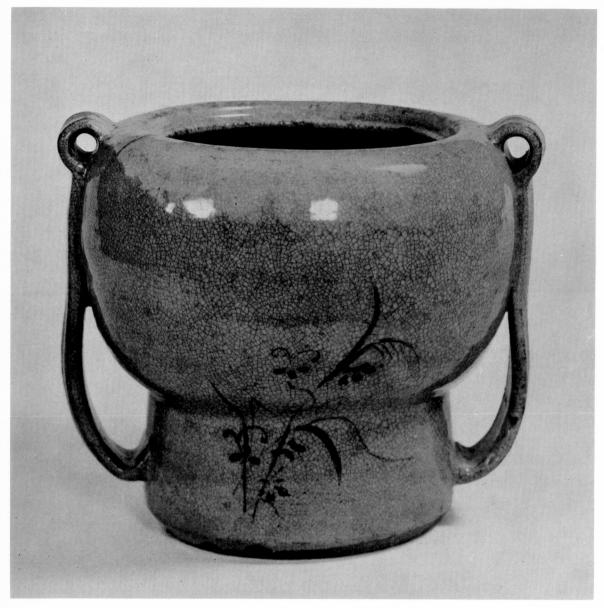

6. *Early Kyō-ware water jar with an underglaze floral design in iron oxide.*

2

The Advent of Pictorial Decoration

The previous chapter leaves unanswered many questions about the earliest Kyō ware, for there is still much to be learned of its origins and development out of Oshikōji ware. One distinctive feature of Kyō ware that can be traced quite precisely, however, is its use of colorful pictorial decoration.

The half-century stretching from the start of the Momoyama period in 1568 into the early years of the Edo period has been called the "renaissance" of Japanese ceramics. Pottery showing a high degree of creativity, both in form and in surface decoration, had flourished in Japan in prehistoric times and during the Nara and Heian periods (eighth to twelfth centuries), but pottery produced during the following centuries was either unglazed or decorated with glaze of a single subdued color. Colored pictorial decoration

made its appearance on ceramics during the Momoyama renaissance, and by the end of the sixteenth century pottery centers at Karatsu in Kyūshū and at the Seto-Mino district of central Honshū were using this form of decoration on a large scale. Designs painted in black or brown iron oxide are to be found first at Karatsu and at Mino, followed shortly afterward by designs done in cobalt blue on the porcelains of Arita, also in Kyūshū. These designs were painted directly on the body of unglazed ware, which was then covered with a transparent glaze and fired.

The mastery of new decorative methods could not help but influence the ceramics of Kyoto because more than half of her potters came originally from the Mino region and were already familiar with the techniques of iron-oxide painting. This type of decoration may

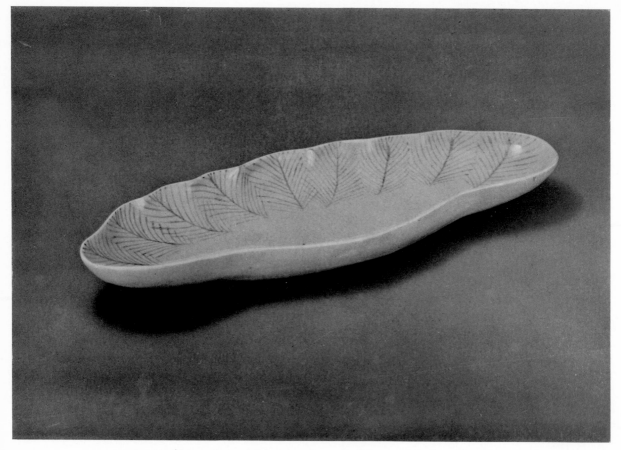

7. *Awataguchi-ware elongated dish with a pine-needle design in cobalt-blue underglaze.*

have been practiced in Kyoto as early as the Momoyama period, although no Kyō pieces with underglaze decoration can be positively identified as being that early. One piece that seems to indicate an early use of underglaze decoration in Kyoto is the water jar shown in Plate 6. The design of flowering grasses was painted with iron oxide on the body; then the entire jar was covered with a clear glaze containing whitish impurities.

The finished pot looks like painted Karatsu ware, but it is almost certainly a Kyō piece. Three features strongly suggest that it was a product of Kyoto rather than of Karatsu, Mino, or Seto. First, the clay is not the kind used in Karatsu or Mino, but is the coarse material used at the Shigaraki kilns southeast of Kyoto. This clay has a high iron content that imparts an orange color when fired, and it was frequently used by later Kyoto potters. The second feature is the shape of the pot. Its mortarlike form, with huge handles extending from the shoulder almost to the foot, is not found elsewhere. Kyoto potters loved unusual forms and delighted in re-creating in ceramics such unexpected objects as bags of gold, hats, or everyday household utensils. The final feature pointing to a Kyoto origin of this jar is the style of its decoration. To be sure, the grasses are painted in quick brush strokes in the manner of Karatsu or early Arita ware, and the design does not seem to have been thought out in advance or executed with much care. And yet the decoration still gives an impression of a hesitant searching on the part of the painter for precision and delicacy, qualities quite different from the spontaneous and bold character of Arita and Karatsu decoration.

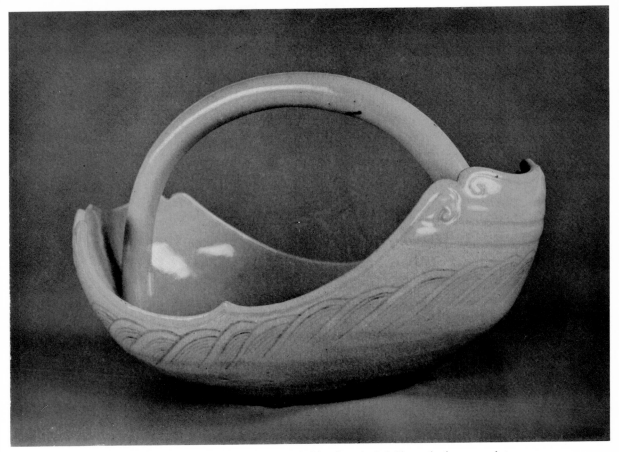

8. *Rihei: Boat-shaped bowl with an arched handle and cobalt-blue underglaze wave design.*

The yearning for refinement so typical of Kyoto taste seems clearly beginning to emerge.

The sparseness of the drawing on the jar and the relative clumsiness of its form strongly indicate an early date; the experimental qualities that it seems to exhibit were soon to be replaced by designs and shapes of far greater sophistication. The rapid improvement is illustrated by the elongated dish in Plate 7. It was made in a mold rather than on the potter's wheel, and the complexity of the shape, with its thin sides of fine white clay, testifies that Kyoto potters were fast acquiring a high degree of technical skill. The design of cobalt-blue pine branches is reminiscent of contemporary stage scenery. Subtle touches characteristic of Kyoto taste are evident: the harmony of the curved branch tips with the wavelike rim of the dish and the

absence of decoration in its central area bespeak a remarkable sophistication.

An inscription on the box for this dish records that it is the work of Kuzaemon of the Awataguchi kiln, but the dish itself has no impressed seal. That fact in itself is important. The use of potter's seals on Kyoto pieces probably did not begin until the Keian era (1648–52), and the lack of a seal on this dish suggests that it may have been made even earlier. This fact, coupled with the name of an Awataguchi potter on the box, points to an identification of the dish as one of the earliest examples of Kyōyaki.

Documents dealing with Awataguchi pottery and preserved at the nearby Shōren-in temple record the information that the kilns were started early in the Kan'ei era (1624–44) by a Seto potter named Sammon-

jiya Kuemon. Early Kan'ei is, of course, too late to be accurate, but the name of the potter does seem authentic. Moreover, when written in Japanese, the name Kuemon is almost identical to the Kuzaemon who is credited with making the flat pine-branch dish described above. If the supposition that Kuemon and Kuzaemon were actually the same person is true, the historical importance of the dish in question is greatly enhanced.

Another interesting example of early Kyō ware is the boat-shaped bowl with arched handle shown in Plate 8. According to tradition and the name inscribed on its box, the bowl is the work of the Takamatsu potter Rihei, who made the Kōchi-style incense container in the shape of a badger illustrated in Plate 1. The bowl is superbly shaped and has a skillfully drawn wave pattern in underglaze blue on its exterior surface. In quality it is the equal of the pine-branch dish by Kuzaemon.

It is believed that Rihei was selected by the head of the Matsudaira family to make pottery decorated with overglaze enamels, a technique to be described at greater length in the following chapter. Because most of his surviving works are of this type, this bowl with underglaze rather than overglaze decoration was probably made either just before or just after he was employed by Lord Matsudaira. Like Kuzaemon, Rihei had worked at Awataguchi, a fact indicating that the Kyoto kilns had perfected the techniques illustrated by these two pieces at least by the mid-sixteenth century, and possibly earlier.

Additional confirmation of the early perfecting of these techniques is to be found in the *Kakumei-ki*, the diary of the monk Hōrin mentioned in the preceding chapter. The entry for the New Year of 1646 tells of a dealer's presenting a gift of a bowl decorated with a plum design. A later entry identifies the bowl as coming from the hands of Seibei, a potter working at the Yasaka kiln in Kyoto, but it is impossible to verify from either entry whether the decoration was done in underglaze iron or in cobalt blue. However, the comment on the bowl's plum design strongly suggests that by 1646 decorated pottery was being made in quantity in Kyoto kilns and that it had some popularity.

The three pieces just discussed (Plates 6–8) have designs in underglaze cobalt or iron oxide. In the Kyūshū kilns, painting with iron oxide appeared first at Karatsu and was followed some years later by cobalt decoration at Arita. The same sequence probably occurred in the Kyoto region, except that cobalt was applied not to porcelain but to pottery. After both painting methods were mastered, it was possible to combine the two; since no technical difficulties were involved, the two types of glaze were no doubt combined quite early.

The two cups illustrated in Plate 10 may or may not be of as early a date as the three pieces just described, but they are superb examples of the combined technique. Wheel-turned, thin, and finely shaped, they are equal in quality to the pine-branch plate and to Rihei's boat-shaped bowl. The unusual shape of the cups seems derived from a type of Japanese pepper (*sanshō-no-mi*) sliced in two, and the curious painted decoration seems to represent a partially raised curtain supported by the undulating rim. The top section of the curtain is in cobalt blue, the mid-section uncolored, and the bottom is a rusty-brown iron oxide. Previously, designs had been done in narrow lines of color, but in these cups broad areas are employed and color plays a more important role in the decoration. The decoration, indeed, is no longer just a pleasant addition to the object but has become an essential feature of the cups, as important a vehicle for their style as their shape.

The mention of the term Kyōyaki immediately evokes in the popular imagination the richly colored, overglaze enamel pottery of Ninsei and his imitators. It is unfortunate that only these glamorous later pieces should be remembered, for the earliest examples of Kyō ware are actually the iron-glaze tea caddies, the subtly colored copies of Korean bowls, and pieces using simple underglaze decoration painted in iron oxide and cobalt. The beauty of pottery with underglaze decoration deserved greater recognition and better appreciation, especially in view of its important role in the early development of Kyoto ceramics.

9. *Early Kyō-ware sakè bottle with bamboo designs in underglaze iron oxide.* ▷

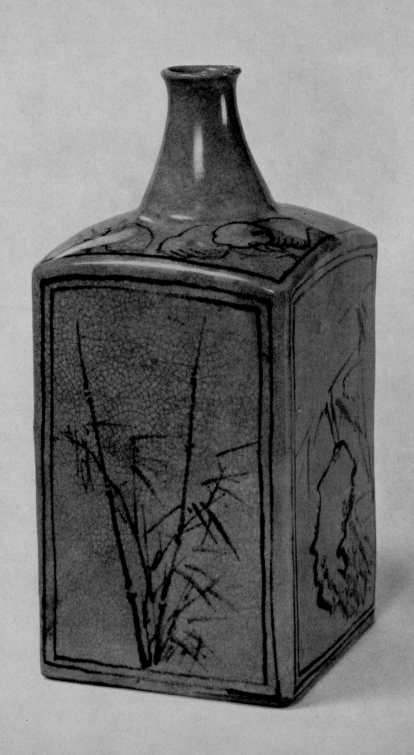

3

Early Overglaze Decoration

Not long after the techniques of underglaze painting were mastered, decoration over the glaze made its appearance on Kyoto ceramics. This method required that the object be fired first with a thin transparent glaze before the colored glazes, often called enamels, were applied. It was, of course, possible to start with an iron or cobalt design under the transparent glaze, and this was sometimes done. After the colored overglazes had been applied, the piece was refired at a temperature lower than the initial firing in order to fuse the enamels. Overglaze enamels had been used on white porcelain by the Chinese at least since the Ming dynasty and by Japanese ceramists of the Kakiemon family of Arita since the mid-seventeenth century. Never had they been used to any extent on pottery. The potters of Kyoto were the first to apply them to

pottery on a large scale, and the results were so successful that overglaze decoration soon became one of the main distinguishing features of Kyō ware.

Tradition has it that the great Ninsei learned the secret of overglaze enameling from an Arita potter, probably someone who was a member of the Kakiemon kiln. Quite recently, however, this interesting bit of lore has been proved false on two counts. Enamels were being used in Kyoto before Kakiemon I, founder of the famous line of Arita potters, produced his first colored porcelains. Furthermore, they were being used on Kyō ware before Ninsei established his kiln at Omuro on the west side of Kyoto. Given this new evidence, it is on his extraordinary skill as a decorator rather than on his talent as an innovator that we must consider Ninsei's fame to rest.

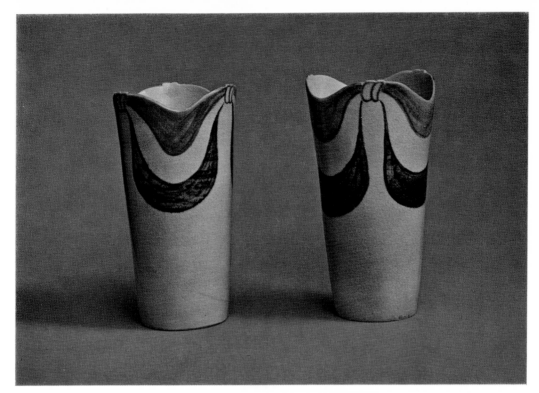

10. *Early Kyō-ware cups with underglaze designs of partially lowered curtains painted in iron oxide and blue cobalt. These cups are among the finest surviving examples of simple early underglaze techniques. The brown, white, and blue stripes of the curtains are beautifully echoed in the gently curving rims of the cups.*

Early Overglaze Kyō Ware

As stated earlier, Oshikōji pottery, influenced by Kōchi ware from southern China, is believed to be the direct predecessor of Kyō ware. The techniques used in making Kōchi are not quite like that of overglaze enamels, but if the Kōchi glaze were to be applied with the tip of a pointed brush instead of the usual wide, flat brush, the result would be a color design not very unlike that produced with overglaze enamels. Furthermore, the mastery of underglaze decoration supplied the basis for the development of overglazing techniques, and the importation of large quantities of Chinese enamel porcelain added impetus to this development.

Precisely when overglaze enamels first came to be used in Kyoto is difficult to determine. Turning once again to the *Kakumei-ki,* which provides some of the best information on Kyoto pottery of the first decades of the seventeenth century, an entry made in 1639 records that a cetain Yamagata Hayatonoshō gave a brazier with overglaze decoration in red as a New Year's gift. The status of the donor makes it unlikely that the brazier was an expensive Chinese import, and the use of the Japanese word *hibachi* for brazier further argues against a Chinese origin. Although the diary does not specify the type of ware, the brazier was most probably made either in Kyoto or in Arita. Kakiemon I succeeded in perfecting red enamel for overglaze decoration toward the middle of the seventeenth century, but since the brazier must have been made before 1639, it was more likely made in Kyoto.

11. *Early Kyō-ware water jar with designs in both overglaze and underglaze. (Left) front, with overglaze design of a fence and cherry blossoms. (Right) back, showing a bamboo tree in underglaze iron oxide and cobalt.*

The *Kakumei-ki* also records in 1640 that one Seibei, probably an antique dealer from the southern part of Kyoto, visited Hōrin, author of the diary, in the company of the lord of the Kaga clan and brought as a gift a pottery incense container. On its base was the ideogram for "longevity" written in cinnabar, meaning a cinnabar-colored glaze. If the piece was Japanese rather than Chinese, it could well have been made in Kyoto. In the preceding year Hōrin wrote of purchasing an underglaze blue incense box and clearly identified it as Imari ware, the general name given to Arita porcelain shipped to other parts of Japan from the port of Imari. Had the box with the cinnabar ideogram been made at Arita, it seems reasonable to expect the priest to have identified it as Imari.

Although such reasoning depends more on supposi-tion than on precise evidence and consequently cannot be considered conclusive, it is certainly not impossible that both the brazier and the incense box could have been Kyō ware. In any case, there is definite proof that kilns designed for firing overglaze enamels were functioning in Kyoto at this time. In 1640, the diary states that an art dealer brought Seibei (the potter from the Yasaka kiln, not to be confused with the curio-dealer Seibei, another visitor of Hōrin's) to the Kinkaku-ji temple to demonstrate how a tea caddy and incense container were made on a wheel. The potter also built a kiln on a hillside within the temple precincts, and there he fired three incense containers to which colored glazes had already been applied. Because this demonstration took place on the grounds of the temple, the kiln must have been the small and

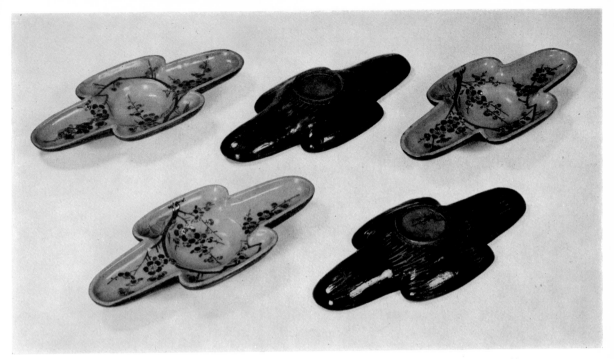

12. *Set of early Kyō-ware side dishes in the shape of stylized clouds with an overglaze enamel decoration of plum blossoms.*

fairly portable type used for overglaze firing. The boxes made on this occasion are mentioned again in an entry for 1644, and described as being shaped like wisteria pods with glazes of purple and green. Although they may not have had brushwork decoration, it is clear that multicolored overglazes were used.

The scraps of evidence contained in the diary of the priest Hōrin suggest that overglaze enamels on Kyō ware began to appear in increasing quantities during the 1630s. Unfortunately, no documented examples remain to corroborate the diary entries.

One piece generally believed to be one of the earliest existing examples of overglaze Kyō ware is the freshwater jar in the shape of a barrel with two handles illustrated in Plate 11. Like the one in Plate 6, this jar is rather carelessly made, and its base is roughly finished.

During firing, the foot of the piece stacked within it adhered to the bottom of the jar and remains there today. The clay, although white, is coarser than that normally used by Kyoto potters, and the transparent glaze seems to have been sloppily applied. Patches of the back of the jar are unglazed, apparently due to carelessness. This rather amateurish treatment and indifference to detail would not have been tolerated by later Kyoto potters and consequently suggests an early date.

A particularly interesting feature of the jar is the fact that the design on one side is executed in underglaze and on the other in overglaze. The right-hand plate shows the underglaze side, where a diminutive bamboo tree, barely visible, is outlined in iron oxide and its leaves and branches painted in cobalt. The stylized tree

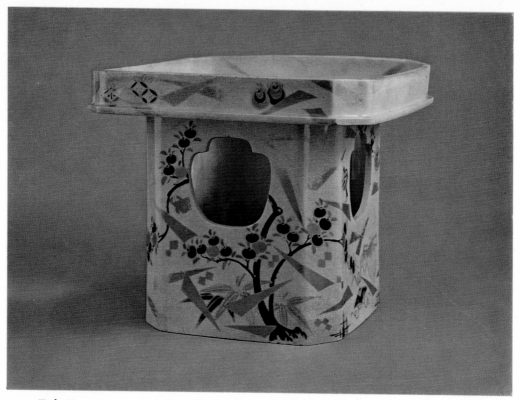

13. *Early Kyō-ware ceremonial offering stand with overglaze decoration in a design of mandarin-orange trees and bamboo. Such stands were usually constructed of thin strips of white cypress wood, and the potter was clearly trying to capture in ceramics the illusion of an object made of wood.*

14. *Early Kyō-ware hanging vase in the shape of a quiver. This is an excellent example of the imaginative adaptation of varied shapes by Kyoto potters. Here, thin slabs of clay were skillfully joined to form a hip quiver. The painted decoration in quiet tones of green, blue, and gold consists primarily of pine, plum, and peony motifs. Tekisui Art Museum, Ashiya.* ▷

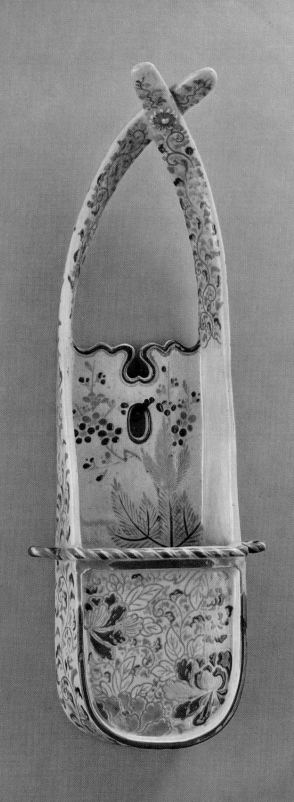

is so out of scale that one must conclude that it forms only a small part of an unfinished design. In contrast, the design on the overglaze side (left-hand) is large, well composed, and complete. It represents a cherry tree in full bloom behind a rough fence, and is executed in a lavish array of colors—red, green, blue, purple, gold, and silver.

There are a few examples of Kyō ware that combine underglaze and overglaze in the same design, but it is most unusual for both to be used separately on a single piece. This fact, coupled with the oddly proportioned bamboo, makes the jar stand out as a unique and not entirely successful experiment. Despite the range of bright overglaze enamels, the brushwork is unsure and lacks the refinement of the painted designs on later Kyō ware.

Basic Characteristics of Kyō Ware

Before turning to a consideration of the various types of enamel ware produced in Kyoto, two characteristic features of Kyōyaki should be noted. First is the common technique of covering one area of a piece solidly and thickly with a monochrome glaze, most often green or deep blue. The small dishes illustrated in Plate 12 are typical examples: on their undersides, thick green and blue glazes meet in a comb-tooth pattern. The inside of Ninsei's famous incense box (Plate 46) also shows the use of a thick peacock-blue glaze.

The second characteristic feature of Kyō ware is the low-relief effect of many overglaze designs. This technique of painting the design in very thick applications of glaze appears most frequently in the handling of flower petals and vine motifs, and was done intentionally to add vitality to the decoration. It is a device unique to Kyōyaki and does not appear in the overglaze decoration of Arita or Kutani ceramics. The use of thick colored glazes undoubtedly stems from the influence of Kōchi ware of southern China, while the idea of applying decoration in low relief probably was borrowed from Japanese lacquer craftsmen who often built up their designs by repeated applications of lacquer.

4

The Variety of Kyoto Ceramics

By the early 1640s, the potters of Kyoto had mastered techniques enabling them to make highly varied products ranging from iron-glaze tea caddies and bowls in the Korean manner to wares decorated in underglaze or overglaze or combinations of the two. The variety of the ceramics they produced brought about an increased demand, and their knowledge of overglaze-enamel techniques enabled them to establish their independence from foreign models and from the ceramics made at other Japanese pottery centers.

The earliest kilns were located in the Awataguchi district on the eastern edge of Kyoto. Gradually the increasing demand for locally made ceramics encouraged the construction of new kilns at Yasaka, Otowa, Kiyomizu, and Seikan-ji, all in the Higashiyama area just south of Awataguchi. Further to the

north and northeast, kilns were built at Mizoro-ga-ike and Kurodani. These were all commercial kilns, in contrast to the official kilns established for the exclusive use of the imperial family or for certain powerful clans. One of the official kilns was that built by Emperor Gomizuno-o at the Shūgakuin Detached Palace in 1627. Another was built by Emperor Gosai at Nogami. No records remain to document the founding of the commercial kilns operated by private families; most of them arose during the three or four decades encompassing the Kan'ei and Kambun eras of the middle seventeenth century.

Although each kiln gave its name to its products, the wares the Kyoto kilns made were so similar that it is almost impossible to distinguish one from another without the aid of impressed seals or inscriptions on

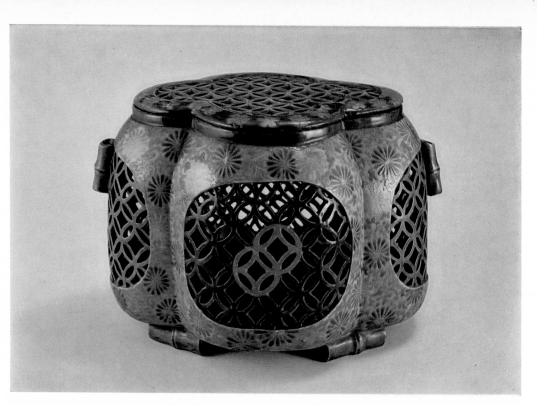

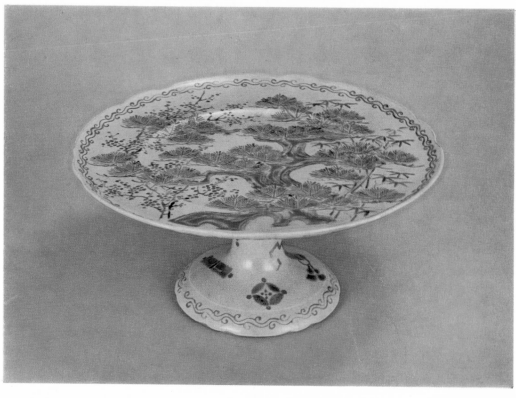

◁ *15. Early Kyō-ware hand-warmer in the shape of a pumpkin, with openwork panels in the "seven jewels" pattern and floral decoration. This piece is a ceramic tour de force of technical complexity and decorative brilliance. At first glance it appears to be of carefully lacquered wood, and only after close inspection does the viewer realize that this object is molded of very thin slabs of clay. The feet and handles, made to look like sections of bamboo, are painted in thick, green Kōchi-style glaze, and blue and gold sixteen-petal chrysanthemums are in overglaze relief. Kyoto City University of Art.*

◁ *16. (Below) Early Kyō-ware stemmed plate with pine, plum, and bamboo overglaze enamel decoration. The piece is made of such thin clay that its outer edge had to be supported from below during firing in order to prevent sagging. The composition of the three symbols of good fortune—pine, plum, and bamboo—is well adapted to the circular space and is enclosed in a border of wavelike lines.*

storage boxes. During the early years, no seals were used. As noted earlier, the pine-branch dish made by Kuzaemon at Awataguchi (Plate 7) bears no seal but does have the name of the kiln inscribed on its box.

We can only surmise the reasons that seals were not used on Kyō wares from the outset. Perhaps they were omitted because early pieces were usually custom-made and the use of a seal might prove insulting to the patron who had commissioned the individual piece. Further, with private patronage there was no need for any sort of commercial trademark. The conditions of land ownership may also have had some bearing on the matter. Landholding in and around Kyoto was very strictly regulated, and most of the early commercial kilns were forced to attach themselves to powerful temples or to certain clans. The Awataguchi kilns were built on lands belonging to the Shōren-in temple, and the Kiyomizu, Otowa, and Yasaka kilns were attached to the Seikan-ji; the Mizoro kiln functioned as part of the Hataeda clan's estate. In an arrangement benefiting both parties, potters supplied the wares needed by their protector-landlords.

The close association between Kyoto's cultured secular society and her temples resulted in a widening market for the wares produced by private potters. Even members of the imperial household may have taken part in the distribution of ceramics, which was initially a private rather than commercial enterprise and hence did not require the use of identifying seals. As social conditions changed and the demand for ceramics became more general, however, the small, protected trade could no longer remain private and commercial rivalries made seals a necessity.

There remain today examples of Kyō ware that

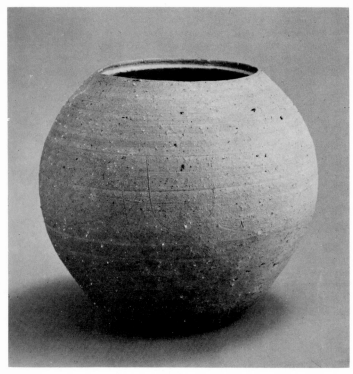

17. *Ninsei: Round water jar in Shigaraki style. Nezu Art Museum, Tokyo.*

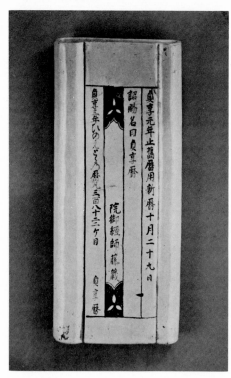

18. *Otowa-ware hanging vase in the form of an almanac book with the calligraphy in underglaze iron oxide.*

19. *Awataguchi-ware wall vase in the shape of a hatchet sheath. The style* ▷ *of the vase is copied from Shigaraki ware. Tekisui Art Museum, Ashiya.*

cannot be classified precisely according to the kiln where they originated. Unidentifiable ceramics with overglaze decoration were formerly lumped together under the misleading designation, "old Kiyomizu ware." In this book, such pieces will be called "early overglaze Kyō ware" and those with iron oxide or underglaze blue cobalt decoration will be called "early underglaze Kyō ware." Furthermore, since the products of the individual kilns are so similar, it seems reasonable to examine them first by shape and design rather than by provenance.

Flower Vases

It is generally believed that the tall vase illustrated in Plate 19 was made at Awataguchi, the oldest of the

Kyoto kilns. It lacks an identifying seal but does have on its box the inscription "imitation Shigaraki." The first Kyō ware was made at kilns established by Seto potters, but due to the proximity of Shigaraki, many potters from that town also participated in the work of the early Kyoto kilns. Thus, the Shigaraki style was added to the repertoire of Kyō wares, which already included ceramics made in the Seto, Chinese, and Korean manners.

Morita Kyūemon, a potter from Shikoku, describes in his diary a visit to the Awataguchi kilns in 1678. While there he learned from a kiln stoker how wares in the Shigaraki style were fired, clear evidence that Shigaraki copies were indeed being made at Awataguchi, probably with clay from the nearby Kurodani area. The piece illustrated in Plate 19 is a

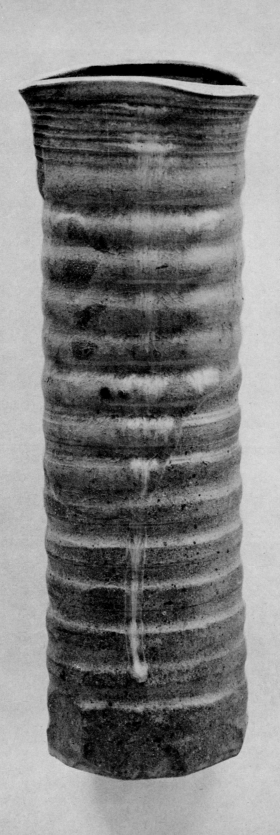

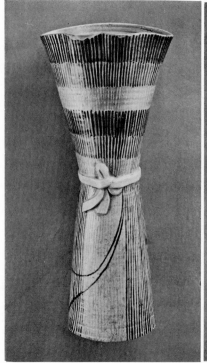

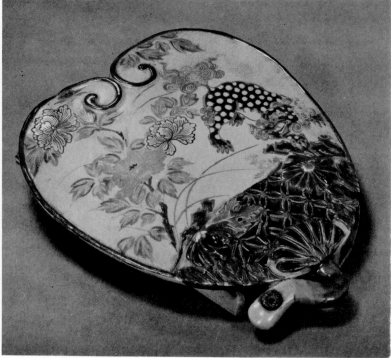

20. Early Kyō-ware enameled wall vase simulating a bunch of strings for wrapping gifts. Tekisui Art Museum, Ashiya.

21. Early Kyō-ware enameled wall vase in the shape of a fan.

hanging vase in the shape of a hatchet sheath, and it may well be one of those copies. It is made of coarse, reddish clay covered with a pale green ash glaze, and in style it is rather more sophisticated than most pottery produced at Shigaraki.

A hanging vase is designed to hang on the wall of a tokonoma, the display alcove in Japanese rooms where treasured objects appropriate to the season or to a special occasion are set out. By tradition, hanging vases were made of green bamboo or of Bizen or Shigaraki ceramics of subdued hues. The inventive, unconservative potters of Kyoto did not feel constrained by such conventions, however, and made their hanging wall vases in a wide variety of shapes and colors. Plate 18 shows one that is hardly recognizable as a vase: it represents a narrow section of an almanac,

its pages turned back to reveal four lines of text painted in underglaze iron oxide. Possibly the vase was commissioned to commemorate a tea ceremony held on the twenty-ninth day of the twelfth month of the first year of the Jōkyō era (1684), a date inscribed on the piece. There is no seal, but the box identifies it as Otowa ware from a kiln just to the east of Kiyomizu temple. This vase is particularly important in the study of the evolution of Kyō ware: its ingenious shape indicates that by the time it was made, Kyoto potters were quite willing to deviate from the canons of tradition.

Curiously Shaped Hanging Vases

The form of the flower vase simulating an almanac is relatively simple when compared to the complex

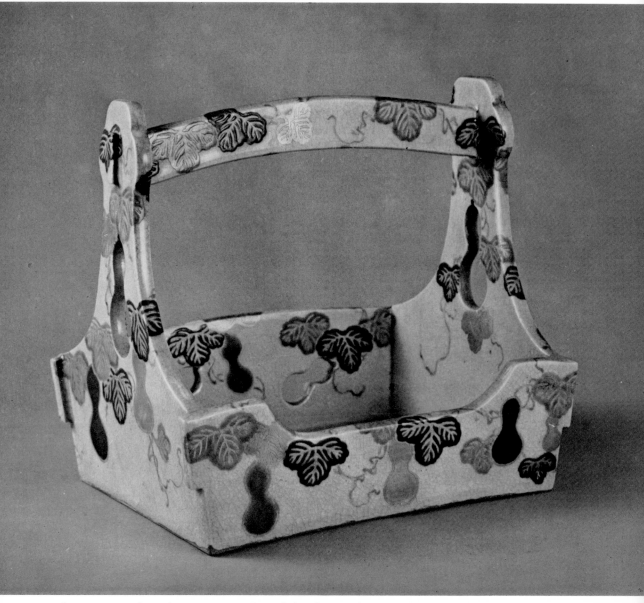

22. *Seikan-ji-ware tray for smoking accessories with gourd-shaped openwork and overglaze-enamel decoration of gourd vines.*

23. *Early Kyō-ware sakè ewer with overglaze-enamel decoration of chrysanthemums and chestnuts.*

forms of the pieces illustrated in Plates 14, 20, and 21. Plate 20 shows a vase with a flat base that allows it to stand upright as well as with a hole in the back for hanging. Its shape represents a bunch of brightly colored paper strings used in wrapping gifts. Both form and color are extraordinary; an inscription on its back, "made in the Genroku era," is a hint of the general flamboyance of that period (1688–1704).

The vase in Plate 14 is of a shape rarely seen today, that of a quiver to be hung at an archer's hip. The ceramic version with flowers replacing arrows is a fanciful but entirely practical adaptation of a traditional form. Skill was required to translate the wooden shape into clay, and further skill with a brush was needed to create the subtle design of peony, pine, and plum in blue, green, and gold pigments. Enameled

Kyō ware seems to fall into two general categories: In one a wide range of colors is used, while in the other, exemplified by this vase, colors are few and rather simple. It is impossible to say which of the two types is the older, but it seems likely that the decoration using only a limited range of colors is older, for it is closer to the Kōchi tradition.

Plate 21 represents a rather ornate fan. Like the quiver vase, the colors used in its decoration are relatively subdued. The design, however, is so elaborate as to almost conceal the fact that the piece is actually a hanging vase. The simulated hollow rivet in the handle takes the shape of a chrysanthemum flower, and the complex reticulated design on the lower part of the fan is reminiscent of the popular "seven jewels" circle pattern. Above, a Chinese lion

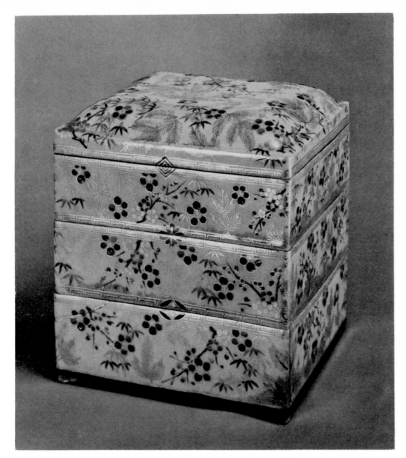

24. *Early Kyō-ware nest of boxes with overglaze-enamel decoration of pine, plum, and bamboo.*

prances among peony blossoms, also a popular theme that was symbolic of good fortune. Only the handle, bent to conform to the oval design, belies the fact that this is not an exact copy of a real fan. The Kyoto family that owns this famous vase displays it proudly every July during the Gion Festival, when all Kyoto residents exhibit their most treasured possessions.

One might argue that it was a reaction against the traditional aesthetics of the tea ceremony that produced these unusual shapes. Advocates of change within the tea ceremony included such tea masters as Kobori Enshū (1579–1647) and Kanamori Sōwa (1584–1656), who sought to replace the restrained, often austere aesthetic established by Sen no Rikyū (1521–91) with a more cheerful elegance comprised of refined shapes and bright colors. It can also be argued

that the ability to create gaily decorated, skillfully designed ceramics may have been responsible for altering the tea taste rather than vice versa. In any case, changes in the aesthetics of the tea ceremony did occur, and many of the objects associated with tea that were produced after the mid-seventeenth century show qualities far different from those of earlier tea utensils.

Influence of Wooden and Lacquered Wares

The flower vases discussed above demonstrate clearly that Kyoto potters did not feel restricted by their medium. Imaginative uses of clay to imitate nonceramic objects were not limited to Kyoto kilns, for Oribe ware includes many bowls in fan shapes or

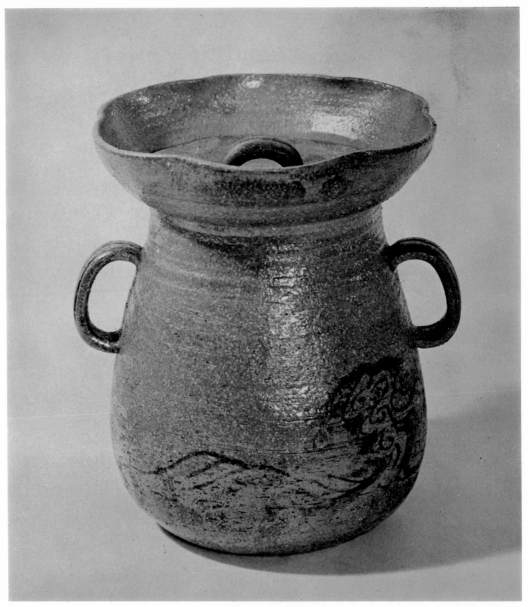

25. *Awataguchi-ware pouch-shaped water jar with an underglaze iron-oxide design of waves. Tekisui Art Museum, Ashiya.*

26. *Early Kyō-ware boat-shaped side dishes decorated with a design of loquats in overglaze and underglaze.*

other odd forms. But Kyoto potters went a step further: They imitated the materials from which the original objects were made.

Plate 13 illustrates a small ceramic stand made in the form of the ritual offering stands used in Shinto shrines. It has no seal and its colors are restricted to blue, pale green, and gold, all features suggesting an early date. These stands were usually made of thin strips of cypress bent to shape and left unfinished. The potter copied this wooden form with thin strips of fine white clay, taking pains to indicate the joints of the original stand and to capture the feeling of the wood as well as the shape of the object. Nevertheless, being a potter, he was unwilling to desert his own trade entirely: The overglaze decoration is unmistakably designed for a ceramic object and would never have

appeared on a wooden stand. Since the piece was made and decorated with such obvious care, it must have been intended for use on special occasions. The top surface is only partially glazed and has a hole in the center, suggesting that it may have been covered with a folded cloth on which rested ornamental rice cakes, which also may have been ceramic.

The portable tray for smoking accessories in Plate 22 bears the seal of the Seikan-ji kiln, but nothing further is known of its history. It too is a translation of wood into pottery, being made of five sturdy slabs of clay and a gently arched handle assembled in woodworking fashion. Gourd-shaped holes have been cut in the sides and an enamel design of gourd plants with leaves and tendrils has been painted on the surface to match the cutouts. The whole effect of the piece is very simi-

27. Early Kyō-ware incense burner in the shape of a cricket cage.

*28. Mizoro-ware water jar in the shape of a bundle tied in a wrapping cloth, decorated ▷
with "lightning" motifs in iron oxide and cobalt. Tekisui Art Museum, Ashiya.*

lar to that produced by contemporary objects made of
wood with inlaid lacquer decoration.

Kyoto potters often drew inspiration from lac-
quer ware. Plate 23 illustrates a sakè ewer of a type
usually made of lacquer. The nest of boxes in Plate 24
is an even better example. Normally, such boxes, used
for packing food, were made of lacquered wood;
Kyoto potters were apparently the first to attempt
copying them in clay. Producing a set of perfectly
matched nested ceramic boxes is an extremely difficult
task for the potter. The drying and firing of clay in-
evitably causes some shrinkage, and precise calculations
are necessary to achieve a correct fit. And further,
since the boxes were intended for carrying and serving

food, they had to be as light as possible; this requires
making the walls of very thin strips of clay that were
liable to warp during firing. The finished product
illustrated here gives not the slightest hint of such
difficulties, however, but demonstrates instead the
Kyoto potter's absolute mastery of his craft.

The outer surface of the boxes is evenly covered
with a slightly bluish, transparent glaze with over-
glaze painting in blue, green, and gold. In contrast to
this fairly restrained palette, the design of pine, bam-
boo, and plum is crowded and gay. As mentioned
earlier, the clay body used for Kyō ware was never the
pure white of porcelain, but either yellow or bluish,
depending upon the effect of firing on the mineral

29. *Mizoro-ware fluted bowl with an underglaze design of pampas grass in iron oxide and cobalt. Kyoto City University of Art.*

30. *Mizoro-ware eight-cornered plate with a pine, plum, and bamboo design in overglaze enamel. Kyoto City Art Museum.*

impurities in the clay. Its surface usually appears soft and has a dull sheen. The brilliant colors of Arita or Kutani porcelain could not be duplicated on a pottery body. The Kyoto potters realized this and contented themselves with the skillful juxtaposition of soft and subtle tones.

The pine, plum, and bamboo motif is auspicious in both China and Japan. Sometimes the three components are scattered throughout the design, as they are on the nested boxes; other times they are organized into a unified group, as on the stemmed platter in Plate 16. Here again, the slender stem and the thinness of the platter show that a wooden form provided the model for this ceramic object. Because the heat of the kiln would have collapsed the thin edge of the platter,

a large tube was used for support, and its imprint can still be seen on the underside of the rim. The ingenuity demonstrated in the making of this piece is but another example of the willingness to tackle difficult technical problems that seems to have been characteristic of the makers of Kyō ware.

The design is fitted with great skill into the circular shape of the platter. In its center stands a venerable pine whose spreading branches enfold the bamboo and the plum on either side, a composition reminiscent of the sparse scenery of the Nō drama. Despite the expansive and carefree quality of the piece, the actual drawing is beautifully precise, and the colors, although limited to green, blue, and a touch of gold, give the impression of a far richer palette.

31. Mizoro-ware square tray with a bamboo design in overglaze enamels.

Technical Skill of Kyoto Potters

The great skill of the makers of Kyō ware is beyond dispute; at times it attains unexpected heights. The ceramic hand-warmer in Plate 15 is a superb example of Kyōyaki craftsmanship at its finest. The piece seems to be made of wood with an ornate lacquer finish, but is of course ceramic. Molding in clay a shape whose sides are less than five millimeters thick is a difficult enough task, but proceeding one step further and adding reticulated panels makes it an extraordinary tour de force. Perhaps even more remarkable is the fact that this elegant piece of ceramic art was actually intended for use as a hand-warmer, with a fire container within it. The shaping and decorating of the work were clearly done with amazing dexterity. Thick Kōchi-

style glazes were used, green for the feet and handles shaped like bamboo sections, blue for the rim, and blue, green, and gold for the reticulated panels. Sixteen-petal chrysanthemum flowers, in blue and gold, stand out in low relief.

The use of enamels to build up relief patterns in the manner of the lacquerer was not restricted only to flowers and arabesque designs. Birds and flowers, and even landscapes, were also handled in this fashion, as is seen on the square sakè bottle in Plate 41. A thick blue glaze, applied with the dry brush technique of the landscape painter, is used to represent the twisted and deeply furrowed trunk of a plum tree. The bottom of the bottle is solidly glazed in green, one of the basic Kyōyaki traditions that seem to be derived from Kōchi ware. The sturdy proportions of the bottle give it the

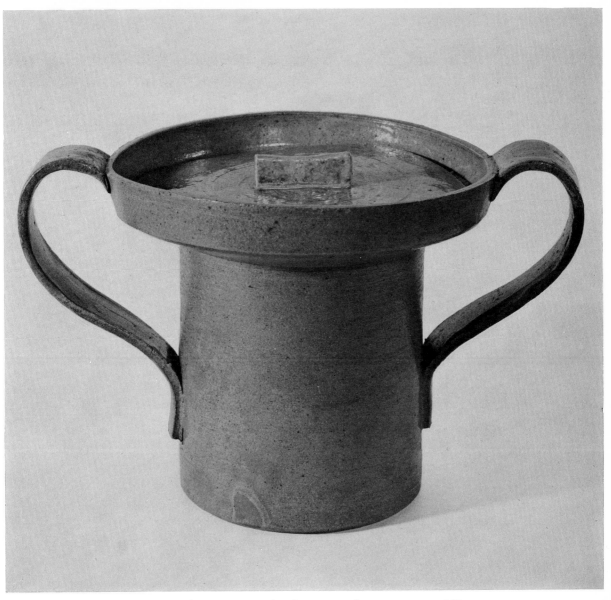

32. *Shūgakuin-ware crown-shaped water jar. Tekisui Art Museum, Ashiya.*

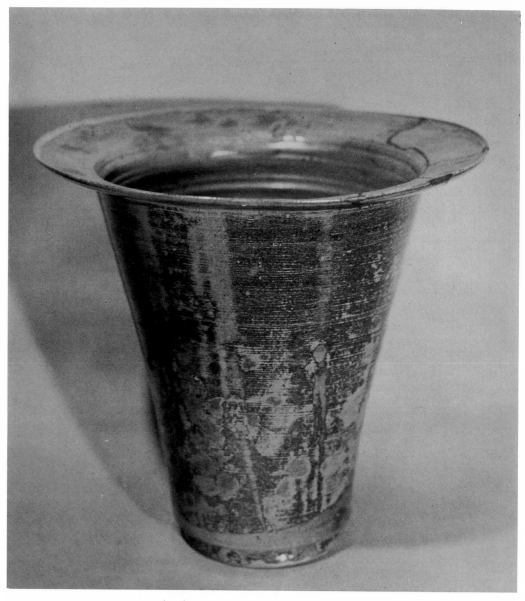

33. Shūgakuin-ware water jar in the shape of a Chinese hat.

34. Nogami-ware cylindrical water jar with poured-glaze decoration. ▷
Tekisui Art Museum, Ashiya.

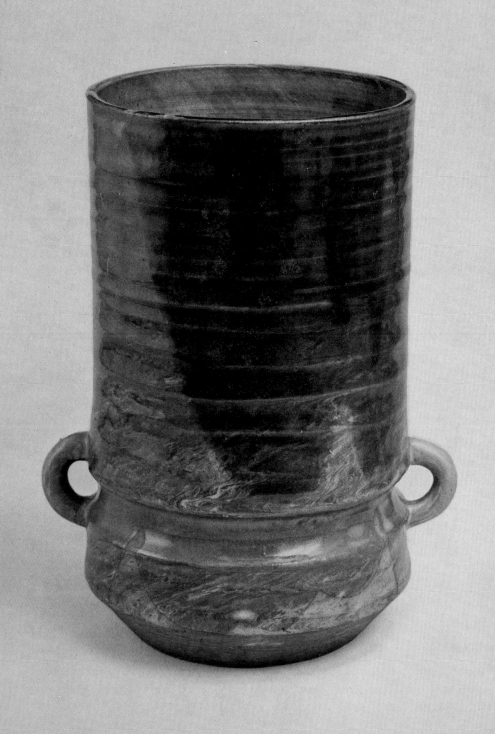

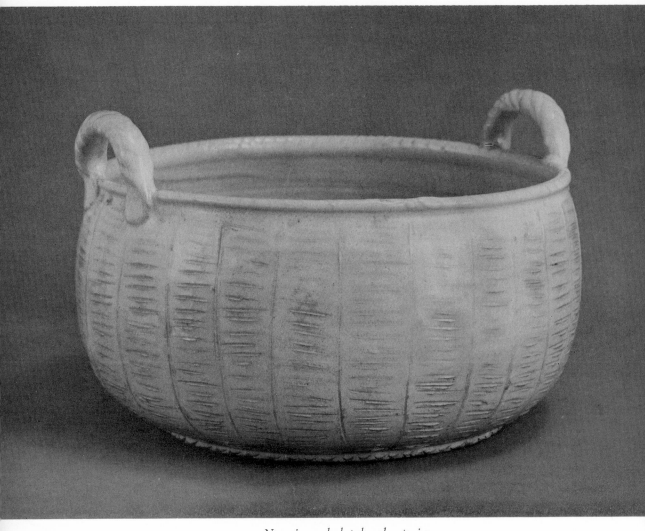

35. *Nogami-ware basket-shaped water jar.*

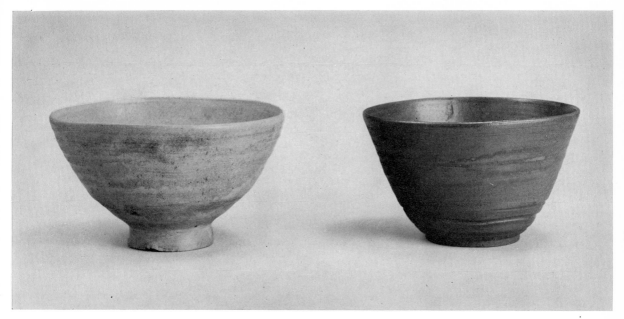

36. Pair of Nogami-ware tea bowls with monochrome glaze.

stability necessary for outdoor picnic use. In every respect, it is an outstanding example of old overglaze Kyō ware.

Water Jars of Unusual Shape

The predilection of Kyoto potters for odd shapes has already been noted. Plate 25 illustrates a covered jar used as a container for cold water in the tea ceremony. Although there is no seal, an inscription on its box identifies the jar as a product of Awataguchi. Made of coarse, sandy clay coated with a yellowish glaze like that found on Korean *irabo* ware, it could pass for a copy of a Korean piece were it not for the design of dashing waves on the side. It is in the shape of a drawstring pouch designed to hold gold dust and, because this form does not appear elsewhere in pottery,

must be considered unique to Kyoto. Ninsei is usually considered the originator of this sort of shape, but the credit should not go to him alone. The tea masters Kanamori Sōwa and Kobori Enshū set the style for Kyō ware, and this sort of shape was also made at kilns other than Ninsei's.

Plate 28 presents another example of an unexpected shape, this one based on a *furoshiki* or square wrapping cloth, with two of its knotted corners forming the cover of a water jar and the other two its handles. The decoration is limited to bands of the stylized "lightning" motif, painted alternately in cobalt and iron oxide. On the inner surface of the lid is the seal of the Mizoro kiln, indicating that the jar is not an early piece but a later one that retains the quiet formality of an earlier time.

The Mizoro kiln is believed to have been founded on

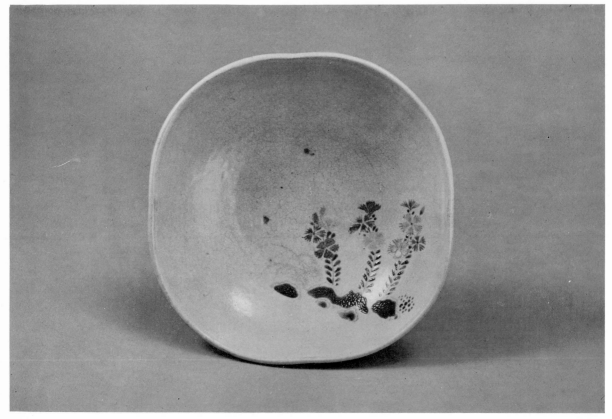

37. *Seikan-ji-ware tea bowl with overglaze decoration of wild pinks. Tekisui Art Museum, Ashiya.*

the banks of the Mizoro Pond some two miles north of Awataguchi in the domain of the Hataeda clan. Ninsei has been called its founder, but tradition has mistakenly attributed many Kyoto kilns to him. Possibly the design of one of the Mizoro ovens or some particular firing technique may have followed his ideas, but there is no proof that he actually established the kiln. The exact location of the original site is not known, for the kiln was subsequently moved, although its potters kept the Mizoro name. According to a late sixteenth-century document, Man'emon—a potter famous as a maker of tea caddies during the middle years of that century—lived close to Mizoro Pond. He produced tea utensils of great distinction, and his wares found their way into the hands of the greatest tea masters. It may well have been Man'emon himself who founded the Mizoro kiln.

The Shūgakuin kiln was established in 1627 at the Shūgakuin Detached Palace of Emperor Gomizuno-o. The water jar illustrated in Plate 32 is an example of Shūgakuin ware. Because the kiln was under imperial jurisdiction, there is no seal to identify it, but the attribution is validated both by the rather conservative style of jar and by the inscription on its box. The shape is rather curious. The severely formal body of the jar and the wide handles with their graceful flaring curve that resemble the pendants on a royal crown are responsible for its being called the "crown-shaped jar." The surface is covered with a warm yellow-brown glaze, applied over a rather coarse clay.

The conical water jar in Plate 33 is from the same kiln and bears the name "Chinese-hat jar." It is made of clay with a high iron content, and threadlike turning marks are visible on the body. The glaze is a somber

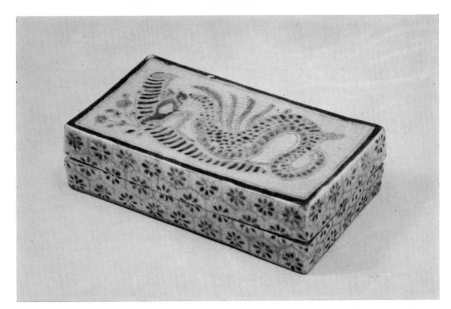

38. Seikan-ji-ware incense box with a playing-card design on the cover. Tekisui Art Museum, Ashiya.

grass-green similar to that found on some Korean ceramics. It is typical of the essentially conservative Shūgakuin ware, which rarely makes use of enamel overglaze decoration.

No trace remains of the Nogami kiln of Emperor Gosai, thought to have been founded during the Tenna era (1681–84) on the eastern outskirts of Kyoto. One of the few remaining products of the kiln is the jar illustrated in Plate 34. Turning marks resembling a heavy coil spring form part of the decoration, and above the base is a deep groove straddled by small semicircular handles. Of particular interest is the use of two differently colored clays kneaded together to produce a wood-grain effect in the finished object. A transparent glaze extends over part of the jar almost to the base, and an amber one covers a smaller area down to the horizontal groove. What inspired the jar's odd shape is not known, but it does have a certain refined severity that seems appropriate to an imperial kiln.

By the last third of the seventeenth century, the activities of the Kyoto kilns founded during the Momoyama period had developed into a flourishing industry. Their products varied little from kiln to kiln except for the work of a few outstanding potters like Rihei, Ninsei, and Kenzan, who utilized common Kyōyaki techniques but managed to transform them into unique modes of personal expression.

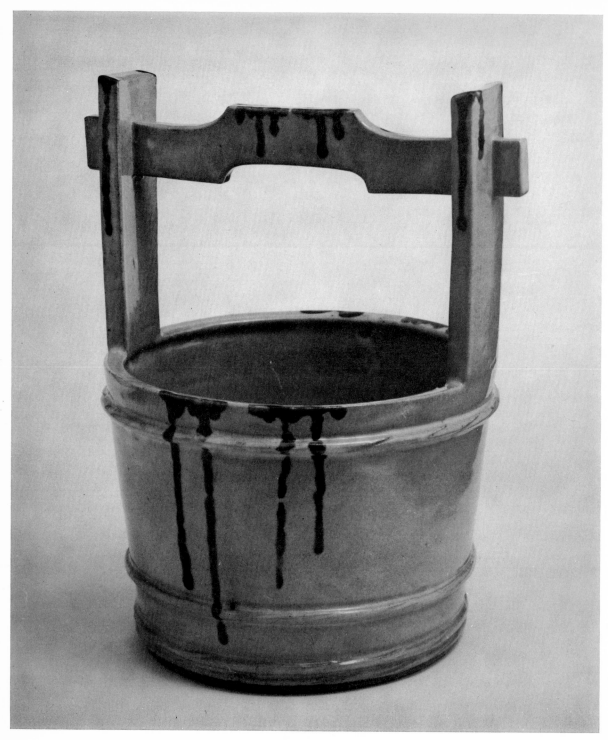

39. *Rihei: Water jar in the shape of a wooden bucket. Tekisui Art Museum, Ashiya.*

5

Rihei, Maker of Takamatsu Ware

Hōrin Shōshō, as noted earlier, was a highly cultivated Buddhist monk of the Kinkaku-ji temple in Kyoto. Devoted to contemporary arts and to ceramics in particular, he apparently enjoyed a wide acquaintance among the art dealers and potters of the city, and his diary, the *Kakumei-ki,* contains numerous perceptive comments about their activities. One name that appears frequently in the diary is that of Sakubei, a maker of tea caddies at Awataguchi. It is quite possible that this Sakubei is the same man who has subsequently come to be known as Rihei. It will be remembered that a potter called Rihei was hired by the head of the influential Matsudaira family to make overglaze ware at Takamatsu on the island of Shikoku. Tradition has it that Rihei, while working at Awataguchi earlier in his career, went by the name Morishima Sakubei.

Further details of Rihei's life are to be found in the biography of his employer Matsudaira Yorishige, which states that Sakubei was the son of a retainer of the first shogun Ieyasu named Morishima Han'ya Shigeyoshi. After the battle of Osaka Castle in 1615, which confirmed the supremacy of the Tokugawa rule, the father returned home to Shigaraki and learned the art of potting. His son followed the same trade, but moved to Awataguchi, where in 1647 he was discovered by Lord Matsudaira and lured into his employ by the magnificent offer of a rice stipend sufficient for fifteen persons. Two years later, Sakubei departed for Takamatsu where he changed his name to Kita Rihei, established a kiln, and began producing pottery for the Matsudaira house.

The late Kōan Yamada, a noted authority on

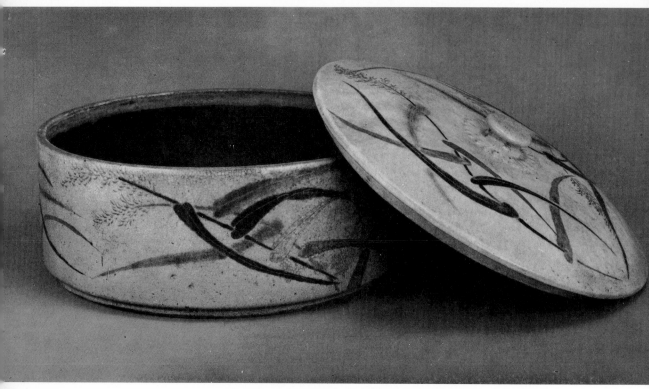

40. Rihei: Large covered dish decorated with an overglaze design of reeds.

41. Early Kyō-ware sakè bottle with an overglaze design of an old flowering plum tree surrounded by narcissus. The age of the tree ▷
is emphasized by the relief effect on its gnarled trunk, caused by the thickly applied enamel. Intended for picnic use, the bottle has
thick, squat proportions designed to improve stability.

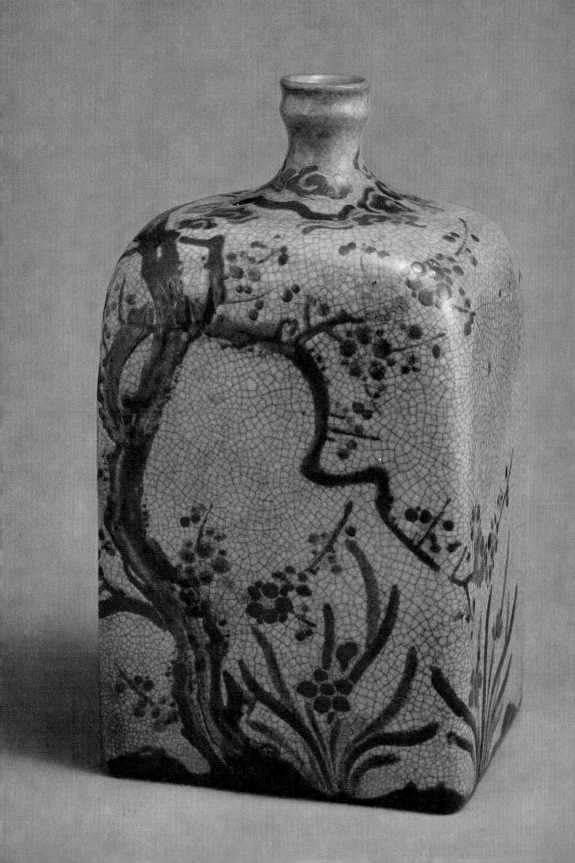

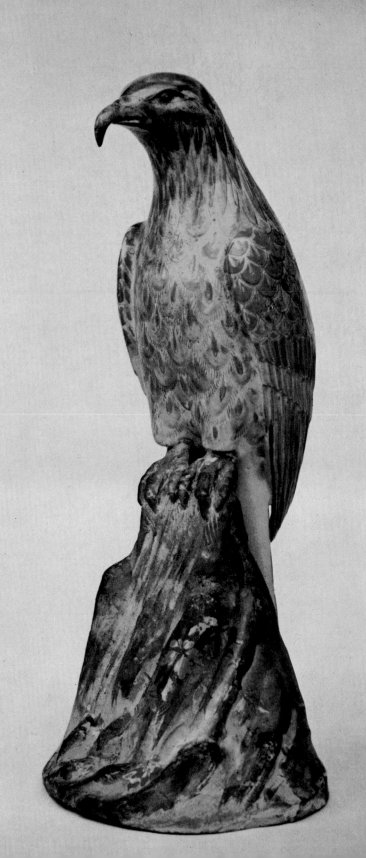

43. *Rihei: Incense box with hollyhock decoration in overglaze enamel. Matsudaira Public Foundation.*

◁ 42. *Rihei: Incense burner in the shape of a falcon. Kōsai-ji temple, Kagawa Prefecture.*

ceramics, was convinced that the Morishima Sakubei (later Rihei) employed by Lord Matsudaira was the same potter as the Sakubei who had made a reputation for himself as a maker of tea caddies at Awataguchi. Yamada argued that the stipend listed for the potter in Lord Matsudaira's biography is so extraordinarily high that the recipient must have been a noted master potter. The Sakubei of Awataguchi, since he had been commissioned to make tea utensils for such connoisseurs as Hōrin Shōshō and Kanamori Sōwa, would have been just such a figure. His skill and reputation would justify a high wage, and it is quite conceivable that the two Sakubeis were, in fact, the same person.

Unfortunately, there is a lack of tangible evidence to support the theory. Almost nothing is known of the biography of the Awataguchi Sakubei, and not a single piece definitively traceable to his hand survives

for comparison with the work of Rihei. Only in the *Kakumei-ki* does his name appear; there, interestingly enough, it is frequently listed between 1640 and 1645, but completely disappears thereafter. Basing Sakubei's connection with Lord Matsudaira and his move from Awataguchi to Takamatsu on this one bit of documentation seems tenuous at best.

In any case, there is little doubt that Takamatsu ware was first made by an Awataguchi potter beginning at some point during the Keian era (1648–52). Despite the distance separating Kyoto and Takamatsu, their ceramic wares were clearly related, and it is firmly established that the Takamatsu kiln was founded by a potter named Rihei. The few remaining works attributed to him, although not actually made in Kyoto, are nevertheless important to a discussion of the evolution of Kyōyaki.

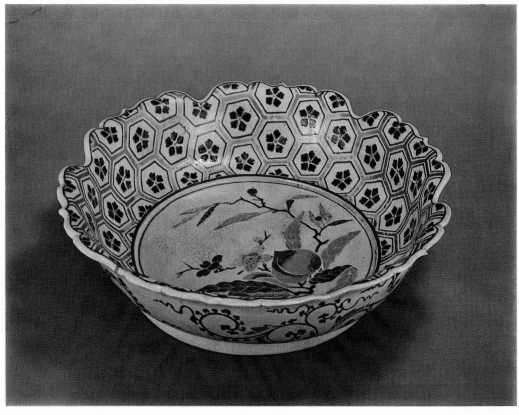

◁ *44. (Above) Rihei: Large covered bowl with overglaze enamel decoration of peonies. Rihei, the originator of Takamatsu ware, is believed to have come from Awataguchi in Kyoto, and his work clearly reflects the style of early Kyō ware. This bowl, one of his masterpieces, is superbly designed with the bold peony design on the exterior making a striking contrast to the silvery glaze on the interior surface.*

◁ *45. (Below) Rihei: Bowl with foliate rim and an interior design of peaches and flowers. The "tortoise shell" pattern that surrounds the central design appears often on Kyō ware, but rarely is it executed with such great precision as on this piece.*

46. Ninsei: Enameled incense box in the shape of a child's ball-bat used in New Year's games. The skillfully drawn decoration of the outer surface incorporates the auspicious symbols of crane, tortoise, and tortoise-shell pattern, and it is beautifully balanced by the rich peacock-blue color of the interior. Nezu Art Museum, Tokyo.

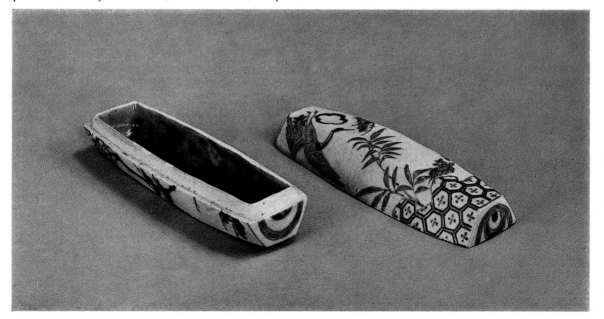

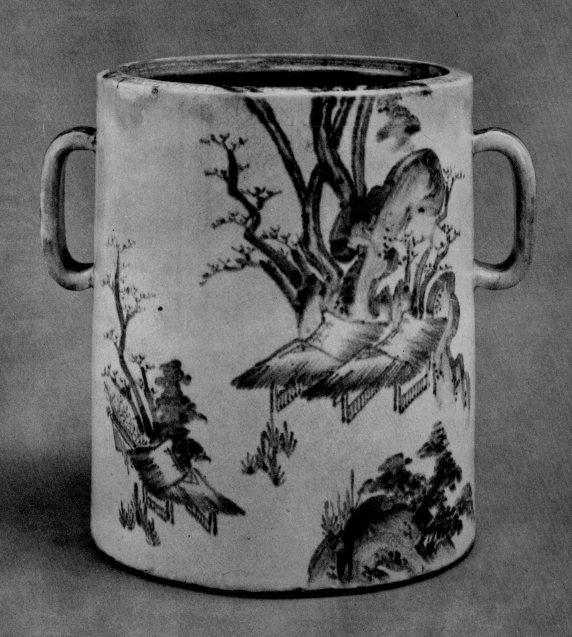

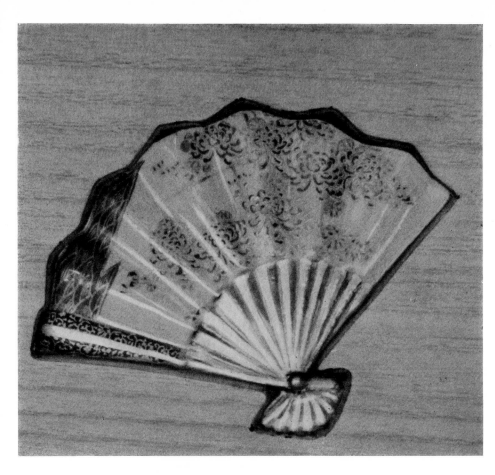

48. Rihei: Enameled nailhead cover in the shape of a fan.

◁ *47. Early Kyō-ware water jar with landscape design in underglaze blue.*

Shown in Plates 40 and 44 are two large covered dishes that originally formed a pair. They have remained in Takamatsu since they were made, and are believed to be examples of Rihei's finest work. The dish with a peony decoration (Plate 44) has a box bearing the inscription: "Shido Kiln covered dish." The kiln is incorrectly named, for it should be Takamatsu rather than Shido, but the box itself is obviously an old one. More to the point, the superb decoration on the dish, done with the skill of a master, attests to its age and quality. The clay and glaze are similar to those used on the water jar in Plate 11, the clay being of the Shigaraki type and the transparent glaze like that used on Awataguchi ware. Because Takamatsu had no facilities for making pottery, Rihei must have

arranged for supplies of clay and glazes before leaving Kyoto. It is therefore hardly surprising that early Takamatsu pieces have often been mistaken for Kyō ware.

Expert handling of the potter's wheel was required to turn these dishes, each of which measures thirty centimeters in diameter. The colors used for their decoration include red, blue, green, and gold. The dish with the peony decoration (Plate 44) is formal, its design almost heraldic; that with the reed design (Plate 40) has a subtle simplicity. On both dishes, the drawing substitutes strength for the refined elegance of the Kyō ware examples illustrated in Plates 21–24. Though somewhat less refined, the designs are carefully executed with forethought and precision. Is it

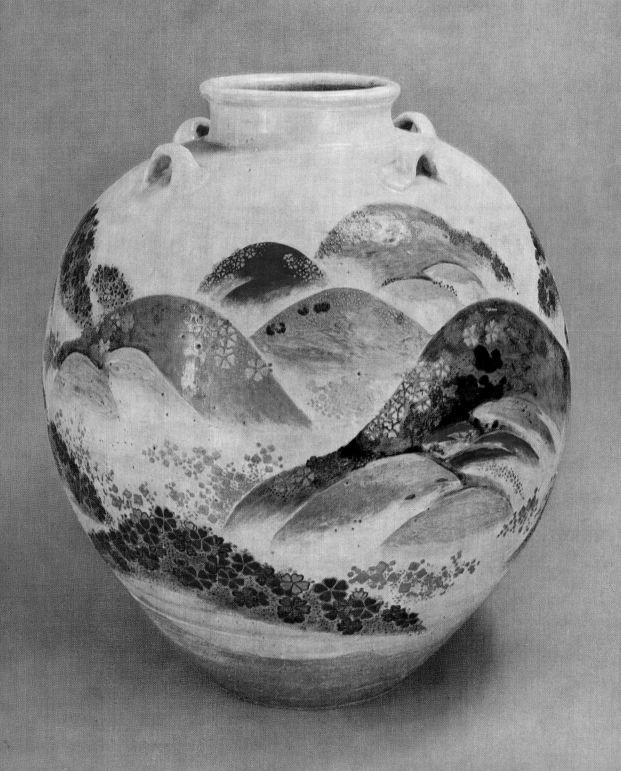

◁ *49. Ninsei: Tea-leaf jar known as Yoshinoyama (Mt. Yoshino). The colorful overglaze decoration on this jar represents the famous cherry blossoms of the mountains around Yoshino in full bloom a favorite theme in Japanese literature. In characteristic fashion, Ninsei first covered the jar with white slip before adding the pictorial landscape in overglaze enamel. Matsunaga Memorial Hall, Odawara.*

50. Rihei: Nested incense boxes with overglaze-enamel design of chrysanthemum and arabesque motifs.

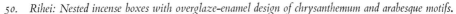

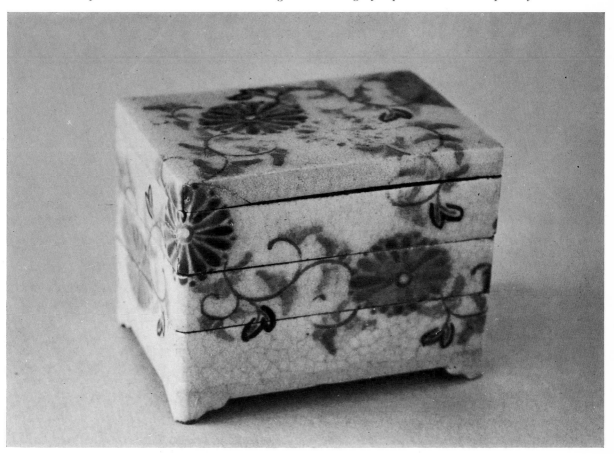

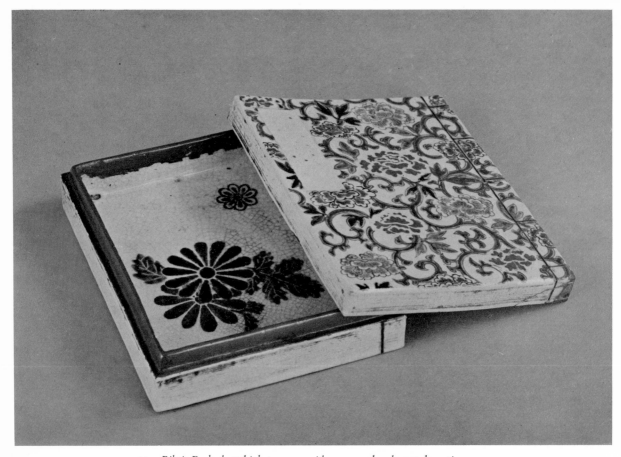

51. Rihei: Book-shaped inkstone case with peony and arabesque decoration.

possible that Kyō ware also passed through this same stage before attaining its extreme refinement? If so, these two pieces well illustrate that particular phase in the development of Kyoto ceramics.

The decoration itself is rendered entirely in overglaze with the inside of the dishes covered with a high-fired iron-oxide glaze of the kind used by Sakubei on his Awataguchi tea caddies. The dish with the peony decoration has a silver glaze over the iron oxide that to this day has not turned black, unlike the silver glazes used by Ninsei. Rihei had evidently discovered a method unknown to Ninsei, additional testimony to his skill and knowledge as a technician.

The fact that Rihei's pieces, made in an official kiln, have no seals adds to the difficulty of identification.

Some pieces are attributed to him merely by tradition, with little or no tangible justification. Others are credited to Rihei on the basis of inscriptions on their boxes, which are not completely trustworthy. There is little doubt that overglaze Kyō-ware pieces without seals, as well as unmarked works by Ninsei, have been mistaken for Takamatsu ware and vice versa. Eventually the confusions may be disentangled and it may be possible to tell them apart. At present, however, considering the difficulties simply of distinguishing between the unstamped products of various Kyoto kilns, thoroughly accurate identification of Takamatsu ware seems rather unlikely.

A particularly interesting example of Rihei's work is a set of boxes (Plate 50) that has remained in the

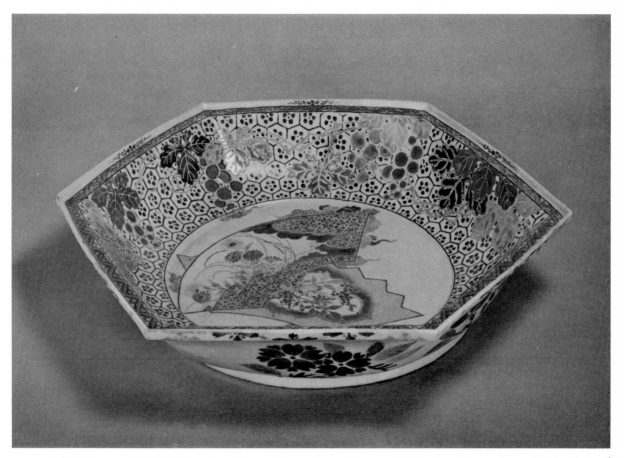

52. *Rihei: Hexagonal bowl with decoration of fans and flowers in overglaze enamel. The inner sides are decorated with a design of grapevines superimposed on a tortoise-shell pattern.*

Matsudaira family collection since it was made. Despite their small size, the three tiers of boxes and their cover fit together almost perfectly. The fine cracks in the transparent glaze and the enamel decoration beautifully harmonized with the shape of the boxes would mark this piece as a superb example of Kyō ware were it not for the fact that it is known to have been made in Takamatsu by Rihei a few years before his death in 1678. This is but another illustration of the difficulty in differentiating Rihei's works from the finest ceramics made in Kyoto.

The decoration on certain of Rihei's pieces is quite unlike anything found on Kyō ware; several of such pieces are illustrated in Plates 45, 51, and 52. The odd form of the inkstone case in Plate 51 is uncharac-

teristic of Rihei's work. The idea of casting a flat box to look like a book may have originated in Kyoto, a supposition supported by the similarity to the flower vase in the form of a book (Plate 53), which is believed to be an example of old overglaze Kyō ware. There is a marked difference in the quality of the drawing on the two pieces. The decoration on Rihei's box lacks the fine precision of that of the vase, apparently indicating that even an expert potter like Rihei may have had difficulty in mastering the art of overglaze-enamel decoration. Written on the wooden box which contains the inkstone case is the inscription: "Obayashi-ware inkstone case." The Takamatsu kiln was built in a section of the city called Obayashi, and the fact that the writer was familiar with the name suggests

53. Early Kyō-ware flower vase in the form of a book. Tekisui Art Museum, Ashiya.

that the piece is genuinely old. In addition, the fact that it was carefully handed on from generation to generation in Takamatsu provides strong corroboration of its attribution to Rihei.

The flower-shaped bowl with a peach design in its center shown in Plate 45 is contained in a box bearing the inscription: "Ninsei: rimmed bowl; peach design." Occasionally Rihei seems to have been glorified with the title "Ninsei of Takamatsu" because his style and technical abilities were thought so close to those of the Kyoto master. At other times his work has actually been ascribed by some connoisseurs to Ninsei himself, as in the cases of the inkstone case and this flower-shaped bowl. The quality of the bowl does not make such an attribution surprising. It is made of soft-looking clay with a pale yellowish glaze and has an overglaze design that is composed with consummate artistry. The deep body of the bowl was turned on a wheel and the rim was later given its petaled shape. Only four enamel colors were used in the decoration: red, blue, green, and gold. Although the drawing is far more skillful than that on the inkstone case, there is

still something about its style that sets it apart from the finest overglaze ware produced in Kyoto. Rather than any lack in Rihei's skill or artistry, the slightly less refined quality of decoration is perhaps the key to Rihei's personal style.

Another fine piece by Rihei, long treasured in Takamatsu, is the hexagonal bowl illustrated in Plate 52. Written on its box is the inscription: "Takamatsu, Ninsei Rihei ware," and the maker of this bowl fully deserves the glorified sobriquet. The crossed fans within the bowl are decorated with a delightful variety of flowering plants, one of them further ornamented with a gold "zigzag" pattern augmented with red and blue colors in the manner of cloisonné decoration. The "tortoise shell" pattern lining the inner wall of the bowl is often found on Kyoto pieces, but here it is handled in a meticulous manner that befits the product of an official kiln. Such precision imparts to the enamel decoration a richness and subtleness that is rarely found even on Kyō ware, and the bowl has been much praised as one of Rihei's greatest triumphs.

6

Nonomura Ninsei

Around the year 1647, when Rihei is thought to have moved to Takamatsu, a new kiln was built in Kyoto that would reconcile the capital to the loss of the potter to the Matsudaira family. The kiln was close to the gate of the newly rebuilt Ninna-ji temple in the Omuro district. Its founder was Tsuboya Seiemon, later to achieve great fame under the name of Nonomura Ninsei. The potters of Kyoto were already masters of their craft, but in Ninsei there appeared for the first time a master potter of genius whose fame as an individual artist spread throughout Japan.

Tsuboya Seiemon was born in Nonomura village in Tamba province northwest of Kyoto. His ancestors were makers of the rugged, utilitarian Tamba ware, well known as a product of one of the "Six Ancient Kilns" of Japan. Little is recorded of Ninsei's life, and the dates of his birth, his arrival in Kyoto, and his death remain unknown. A Ninna-ji document bearing the date 1650 contains the rather cryptic entry: "Arrival of Tamba-ware Seiemon." The phrase can be interpreted in a variety of ways, but it does at least support the tradition that the potter was in Kyoto at that time. Several years earlier an agreement had been reached between the shogunate and the imperial family to let the Emperor Goyozei's eldest son Prince Kakushin become a Buddhist monk on the condition that the Ninna-ji be reconstructed. The reconstruction was carried out in 1646. Two years later, the *Kakumei-ki*'s New Year entry for 1648 mentions a tea caddy of "Omuro ware." This would seem to indicate

54. Ninsei: Tea caddies with Seto-style glaze. Nezu Art Museum, Tokyo.

that Seiemon must have established his kiln at Omuro in 1647, the year following the reconstruction of the temple.

That he was allowed to build a kiln on the grounds of a temple where there resided the elder brother of the then reigning emperor suggests that his reputation as a potter was already of a rather exalted order, an accomplishment that must have required years of training in the Awataguchi district in order to master all phases of Kyō ceramics. In addition, Seiemon notes in his *densho,* a secret journal of technical information that was later passed on to Kenzan, that he had spent time in the Seto region studying glazing methods. It is unlikely, therefore, that he was still a young man when he arrived in Kyoto. The date that he adopted the name Ninsei is as uncertain as his age. Tradition has

it that it was in 1566, almost ten years after founding the Omuro kiln, that he took (or was granted) the name, the first syllable of which was borrowed from Ninna-ji. There is some evidence, discussed later, that he assumed the name even earlier. About Ninsei's later years little more is known except that his death occurred sometime between 1681 and 1688.

Despite the lack of reliable biographical evidence, Ninsei's works remain as the most eloquent testimony to his extraordinary skill and craftsmanship as a potter. Emperor Gomizuno-o, who had earlier founded the Shūgakuin kiln, visited the Ninna-ji in 1657 to examine Ninsei's work and was very highly impressed. Ninsei's other distinguished patrons were such connoisseurs as Kanamori Sōwa and the priest Hōrin, all of whom gave guidance as well as financial support.

55. *Ninsei: Tea caddy in the shape of a peeled tangerine; Seto-style glaze.*
Nezu Art Museum, Tokyo.

Ninsei's Versatility

It is often said that Ninsei's fame rests on his lavishly decorated tea-leaf jars, such as the Yoshinoyama (Mt. Yoshino) jar illustrated in Plate 49, the Yamadera (Mountain Temples) jar of Plate 66, and another called the Wakamatsu (Young Pines) jar. That these are among Ninsei's finest pieces cannot be denied, but his fame should rest primarily on his overall genius as a decorator and on his technical skill in shaping ceramics and glazing them. A glance at tea caddies like those illustrated in Plates 54, 55, and 58 should reveal instantly his talent as a potter.

While he was at Seto, Ninsei concentrated on making tea caddies, for at the time the caddy was considered one of the most important utensils used in the tea ceremony and was much discussed in the *Kakumeiki* and other contemporary records. In Ninsei's little caddies, small enough to be held in the palm of the hand, are concentrated all the highest qualities of his art. For refinement of shape and for quality and control of glaze, the connoisseur of fine ceramics need look no further than these small pieces.

Plate 55 illustrates a caddy with a brown Seto glaze, one of a set of eight, that is modeled on the shape of a peeled tangerine. It was first turned on a wheel, and later vertical lines representing the sections of fruit were lightly incised, each segment being identical in width and contour. The clay is coarse and sandy and the glaze a clear amber color.

Another caddy, called Murakumo (Gathering Clouds), appears in Plate 58. Its name is derived from

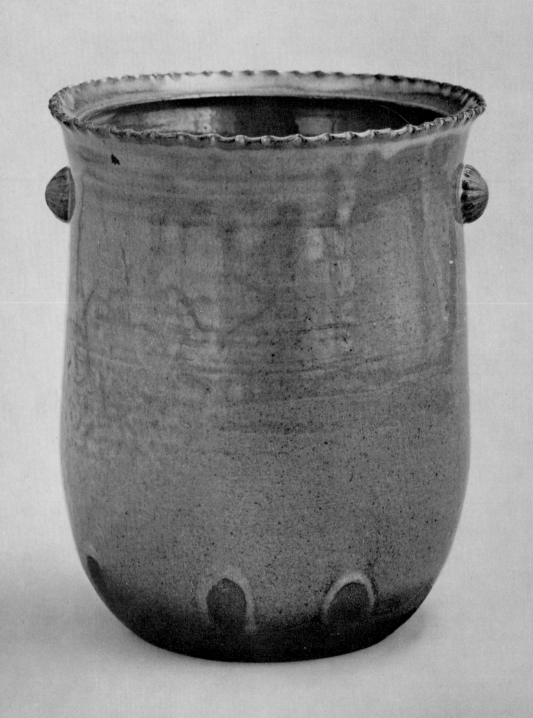

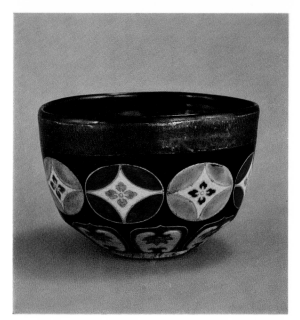

57. *Ninsei: Black tea bowl with stylized floral decorations in enamel overglaze. Although Ninsei made several black tea bowls decorated in similar lacquer style, this one is unique in the acute angle between the base and the body. Also unusual is the band of silver glaze around the rim, a feature possibly inspired by the silver lacquer techniques of Kōetsu.*

58. *Ninsei: Tea caddy with a design of gathering clouds. Ninsei produced numerous tea caddies in the style of Chinese or Seto pieces, but always added a distinctive touch of his own. Here, his skillful intermingling of two glazes produces a dramatic stormy effect.*

◁ 56. *Ninsei: Water jar with a notched rim and straw-ash glaze. Nezu Art Museum, Tokyo.*

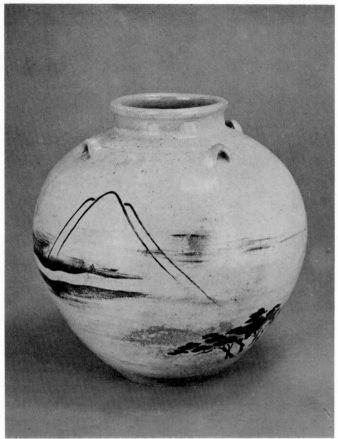

59. *Ninsei: Tea-leaf jar with an underglaze iron-oxide design of Mt. Fuji. Nezu Art Museum, Tokyo.*

60. *Ninsei: Tea-leaf jar in Shigaraki style. Tokiwayama* ▷ *Collection, Kamakura.*

the manner in which the mingling glazes of different colors suggest clouds building before a storm. This effect was achieved with a dark brown iron-oxide glaze and a whitish straw-ash glaze that produced a third color, a rusty red, when they overlapped. Ninsei often took pains to match clay to glazes and in this case he chose a yellowish, firmly compacted clay. This is perhaps his finest caddy, combining as it does subdued and harmonious glazes with a slender, beautifully proportioned shape.

Workshop Techniques

It is of interest to examine in some detail Ninsei's technical background and the problems that he faced in producing the pieces he worked on. During the first half of the seventeenth century, Kyoto and Seto

tea caddies were made on the Seto type of potter's wheel, which was turned clockwise by hand. In Tamba, where Ninsei grew up, the wheel revolved counterclockwise and was turned by foot. It was naturally this type of foot wheel that Ninsei mastered first, and his later use of the Seto wheel necessitated total change of technique due to the different direction of rotation and to the shift from foot to hand power. Basic training and deeply ingrained habits are difficult to overcome, but Ninsei was apparently able to master both types of wheel, using them with equal virtuosity.

The wheel marks on most of his caddies have been obliterated by careful smoothing, and it is therefore difficult to determine the direction of rotation of the wheel on which they were made. Ninsei seems to have made caddies on both types of wheel. On first thought it might seem logical to guess that pieces turned

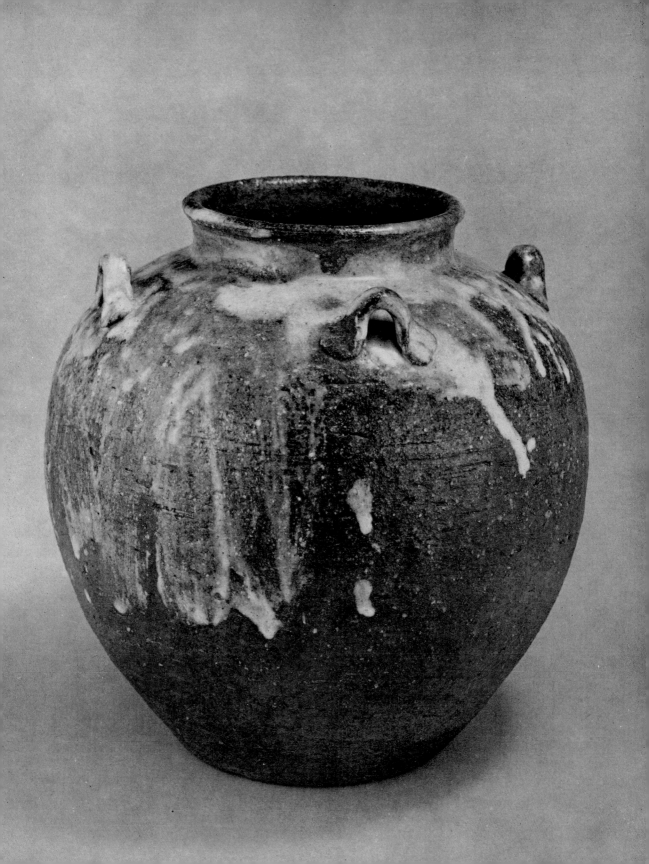

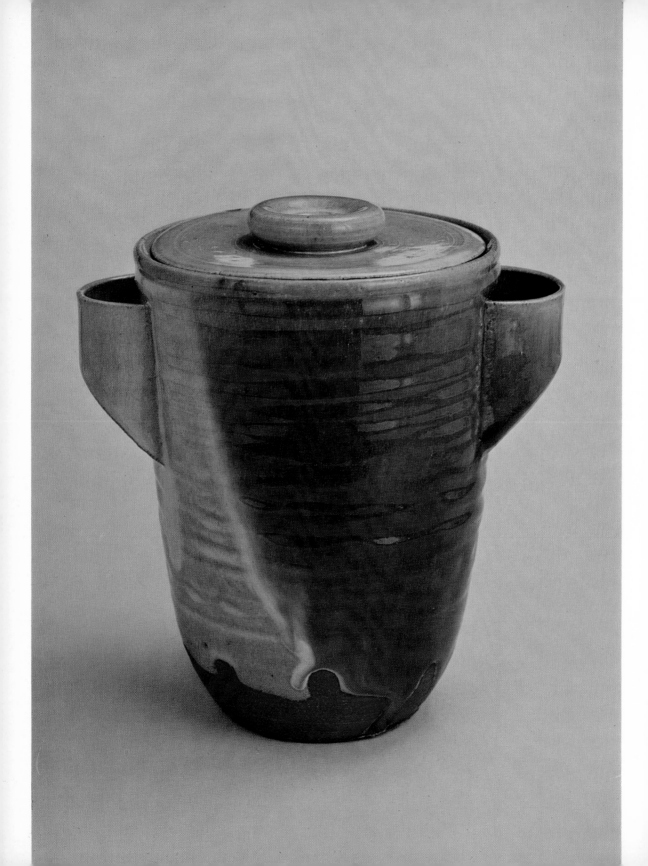

◁ *61. Ninsei: Covered water jar with poured glaze decoration. Ninsei was an avid student of the glazing methods of other kilns and did not hesitate to borrow ideas and techniques. This jar he decorated in the manner of Agano ware from Kyūshū, using straw-ash glazes in green and white, poured over the surface and allowed to run freely.*

62. Ninsei: Large incense burner decorated with Buddhist symbols representing the "Wheel of the Law" and vajras (thunderbolt-like instruments used in Buddhist rituals). This is one of several pieces presented by Ninsei to the An'yō-ji temple in 1657, and illustrates his rapid mastery of ceramic techniques during the first decade after establishing his kiln at Omuro. Fujita Art Museum, Osaka.

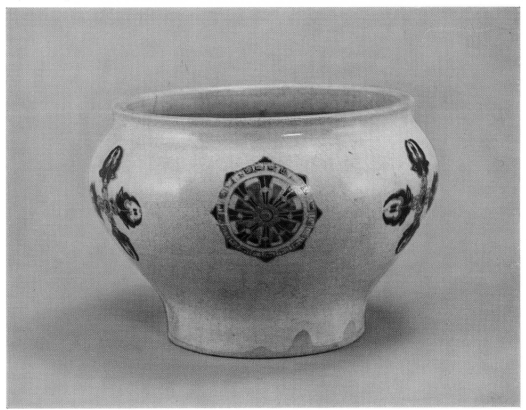

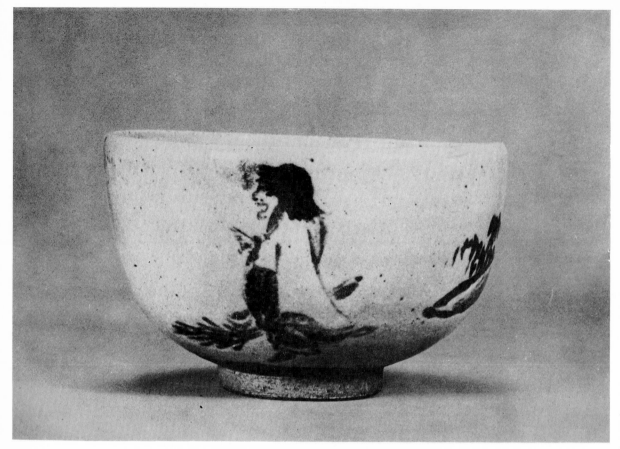

63. Ninsei: Tea bowl with an underglaze iron-oxide portrayal of the Chinese Zen monks Kanzan and Jittoku. Kinkaku-ji temple, Kyoto.

counterclockwise were actually made by Ninsei and the others by his assistants. However, even though it has been proved quite definitively that he did not work alone, Ninsei's skill was so highly developed that he could have used either type of wheel with equal ease.

The water jar of Plate 61 offers quiet but eloquent testimony to Ninsei's versatility. It apparently was turned on a Seto-type wheel and the glazes were allowed to run down the sides freely in imitation of the straw-ash glazes used on Agano ware from Kyūshū. Glazes of all sorts and the methods by which they were applied were matters of passionate interest for Ninsei, and he never hesitated to try out ideas borrowed from other kilns.

Another piece produced on a clockwise wheel that shows Ninsei's love of experimentation is the wide-mouthed water jar of Plate 56, which has a whitish straw-ash glaze probably inspired by one type of Karatsu ware. The clay body is rich in iron, which gives it the purplish-brown color characteristic of Karatsu, but the thin walls and the small flaring rim with its petal-like edge impart a delicacy that is foreign to the Kyūshū ware. Ninsei copied the products of many far-flung kilns but still managed to give each piece a refined, metropolitan air.

This ability to draw inspiration from even the most utilitarian ware can be seen also in the Shigaraki-style tea-leaf jar in Plate 60. Shigaraki clay, with its high feldspar content, was actually used in making the jar, which was expertly turned on a wheel and smoothed, both inside and out, as carefully as the coarse clay allowed. As a result, the heavy, rugged personality of

64. Ninsei: Tea bowl with an overglaze-enamel design of playing cards.

Shigaraki ware, with its characteristic uneven surfaces, is transformed into a well-finished jar that is both light and sophisticated. Another typical Ninsei touch is the white feldspathic glaze, brushed on quickly in the manner of Hagi ware from southwest Honshū. This type of glaze was never used by Shigaraki potters, but it contrasts successfully with the red tone of the body of the jar. Because of the coarse and sandy nature of the clay, it was not considered suitable for use in tea jars until Ninsei tried his hand at it and proved that it could be used. He loved both to experiment and to confound the sage experts who were constantly ready to predict sure failure for any new and untested techniques.

It is probable that Ninsei's mastering of various pottery techniques followed the chronological pattern that had occurred in Kyoto. He first would have learned iron-oxide and cobalt underglazing; having been born in Tamba and apprenticed in Seto, he could not have studied the use of enamels until he arrived in Kyoto.

Representative of Ninsei's underglaze pieces are a tea bowl with a daffodil design in the Tennei-ji temple and the bowl portraying Kanzan and Jittoku, two foolish monks who attained abrupt enlightenment, preserved at the Kinkaku-ji temple (Plate 63). Still another is the superb tea jar with an underglaze of Mt. Fuji in the Nezu Art Museum (Plate 59).

Overglaze Decoration

Unfortunately, nothing is known of Ninsei's first

65. *Ninsei: Tea bowl with enamel-overglaze decoration of linked sachets. The lower half of the bowl is well rounded to fit the hand of the tea drinker, and there is a slight indentation running around the middle. Ninsei was apparently fond of this shape, for he produced many similar bowls. The perfume bags are slightly outlined in gold enamel and richly decorated with a variety of patterns in red, green, blue, and gold.*

66. *Ninsei: Tea-leaf jar known as Yamadera (Mountain Temples). Among Ninsei's famous enameled tea jars,* ▷ *this one is exceptional in its intentionally crowded design and unusual coloring. The drawing closely imitates the Chinese-inspired style of the Kanō school of Japanese painters, and it is possible that a Kanō artist did an initial rough under-sketch of the design. Nezu Art Museum, Tokyo.*

67. *Ninsei: Enameled tea bowl with decoration intended to evoke the Plain of Musashino. Nezu Art Museum, Tokyo.*

attempts to work with overglaze enamels. The one and only dated example of an early piece is the large urn (Plate 62) used for burning incense in Buddhist temples. It bears on its side sacred designs representing the Wheel of the Law *(dharma-chakra)* and symbolic thunderbolts *(vajra),* and on the bottom is an inscription that can be freely translated: "Ninsei, with the priestly rank of Harima Nyūdō, respectfully presents [this piece] made by him for the holy Buddha this fourth day of the fourth month, 1657." Ninsei made offerings of works like this to the Ninna-ji and to two other temples in the hope of acquiring greater proficiency in his craft. The workmanship on the urn was extremely painstaking. Its body is made of fine white clay carefully shaped before the foot was formed. The foot was made by attaching a coil of clay to the fin-

ished body and then turning it again on a wheel to ensure a smooth transition. The resulting join is smoother than that produced by the usual method of finishing the foot separately before attaching it. Once this careful shaping was completed and the inscription added, the urn was glazed and fired in readiness for the enamel decoration and the final light refiring. The alternating designs of wheels and thunderbolts are in red, blue, and green, with touches of gold. Usually, Buddhist incense burners were made of gilt bronze, but Ninsei preferred to be original and make his of soft white clay with the symbols brightly colored.

This single dated example is evidence of the fact that ten years after the Omuro kiln began functioning, it was producing high-quality overglaze ware. However, a close examination of Ninsei's enameled pieces

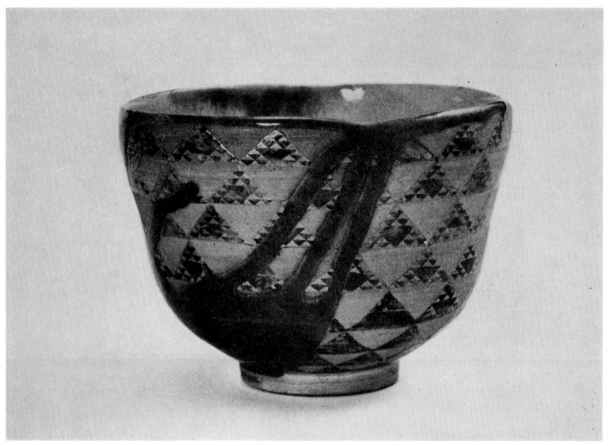

68. Ninsei: Enameled tea bowl with "fish scale" triangles and waves.

reveals considerable variation in quality. Not all of them can equal the incense burner. It is possible to conclude from this unevenness that Ninsei was skilled in shaping and glazing but relatively inept at pictorial decoration—that the inferior designs are his and that the finest ones were executed by a skilled designer in his employ. It is, however, equally reasonable to suppose that the variation in quality is related directly to Ninsei's gradual acquisition of technical skill. Quite apart from such speculations, it does seem probable that an expert decorator was at times hired to paint designs created or suggested by Ninsei himself. Because of Ninsei's fame there has been a tendency to attribute the best pieces to him; actually, however, it is very likely that several apprentices assisted in making the works that bear his seal.

The tea bowl illustrated in Plate 64, known as the Unsun Karuta (Playing Cards) bowl, is decorated with both underglaze and overglaze, a combination unusual for Ninsei. The drawing of the cards is done in cobalt and iron oxide and their outlines redone in gold overglaze, again an unexpected feature. Both the drawing and the coloring are rather clumsy, yet the type of clay, the glaze, and the style are all characteristic of Ninsei's work. By comparison, the bowl with a design of sachet bags, shown in Plate 65, is decorated with great skill; indeed, it is difficult to believe that both bowls bear the seal of the same artist. In such contradictions lie the mystery and the fascination of Ninsei.

The tea bowl illustrated in Plate 57 offers strong support to the argument that there was a highly

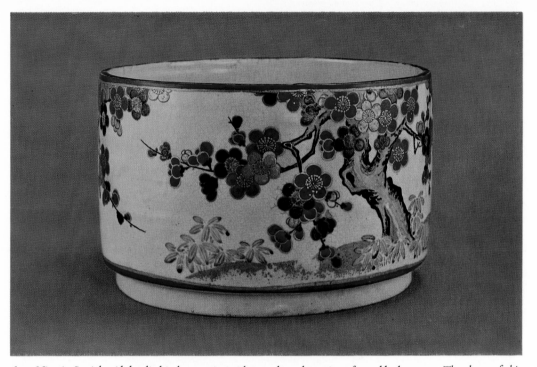

69. Ninsei: Straight-sided cylindrical water jar with overglaze decoration of an old plum tree. The shape of this vessel with its wide and rather high base is unusual for Ninsei. The plum blossoms in red, gold, and silver are in low relief, suggesting the influence of lacquer-ware techniques. Ishikawa Prefectural Art Museum, Kanazawa.

70. Ninsei: Enameled water jar decorated with framed panels of peonies. Here Ninsei is totally successful in achieving ▷ *the technically difficult feat of attaching a flat rim at right angles to the slightly curving sides of the jar. In addition to the technical perfection of the piece, Ninsei's lavish overglaze decorations distinguish it as one of his finest works. The gold clouds in each panel and the relief decoration of the background framing the panels show the strong influence of lacquer-making techniques. Tokyo National Museum.*

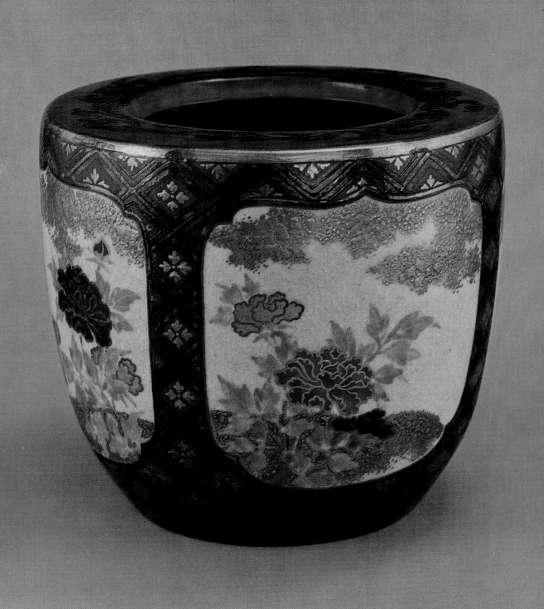

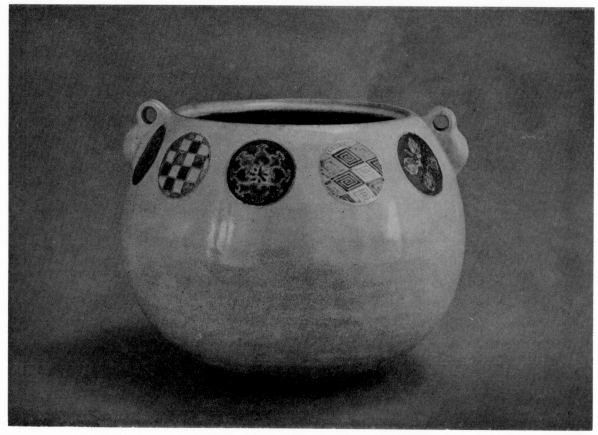

71. Ninsei: Water jar with medallion designs in overglaze enamel.

trained designer present among the Omuro potters. Ninsei often made tea bowls combining a black ground with colored enamels, but this one is atypical of his work in two respects. Unlike his usual bowls, this one tapers sharply from the waist to the foot in the manner of Chinese Temmoku bowls, and it might well have been custom-made for some official who hosted highly formal tea ceremonies. Also, the inside of the foot on a Ninsei bowl is usually not precisely centered, while this one is. The most interesting feature of the bowl is its decoration. The stylized floral design around the middle and the lotus petals below are in color, while the rest of the vessel, except for the silver band around the rim, is glazed in black. The striking contrast of black and silver suggests that the designer

was influenced by the silver lacquer ware produced in quantity some years earlier in the workshops established at Takagamine on the northern outskirts of Kyoto by the master designer, potter, and calligrapher Hon'ami Kōetsu.

In view of the decoration of this particular bowl, it seems quite likely that any specialist-designer in Ninsei's workshop had been trained in lacquer techniques. The famous peony jar illustrated in Plate 70 further supports this view. Enframed floral scenes were a popular feature of Kyō ware, but in this case the gold in the clouds and on the foreground was made to appear as if sprinkled rather than painted on, an effect clearly derived from a lacquer technique. In addition, the stylized flowers within the diamond pattern that

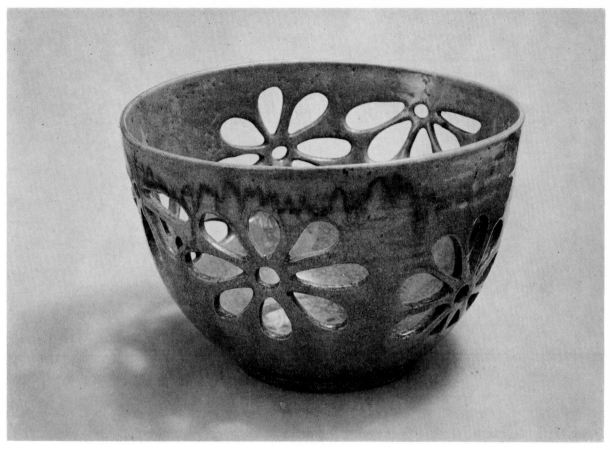

72. Ninsei: Bowl with flower-shape openwork and finely crackled glaze. Nezu Art Musum, Tokyo.

surrounds the floral patterns were borrowed from the lacquer craftsman's repertoire. Other Kyō ceramics made frequent use of gold and silver, but here the metallic glazes are built up as in the fashion of lacquer work. Ninsei's search for creative ideas to be used in his shop led him to explore the fields of lacquer, cloisonné, damascene, dyeing, and weaving, and to borrow from each certain features that he thought could be successfully applied to ceramics.

Skill on the Wheel

From a potter's point of view, the water jar discussed above (Plate 70) is of immense technical interest. The wide horizontal rim at right angles to the sides is an achievement that requires extraordinary skill and absolute control of the wheel. This ability is evident not only in Ninsei's small pieces, such as the tea caddy in Plate 58, but also in his larger works.

The most important, and perhaps the best known, of Ninsei's large pieces are his magnificent tea-leaf jars. Traditionally, such jars, whether made in South China and imported to Japan via the Philippines or made at Seto, were given a subdued monochrome color. Ninsei once again broke tradition to decorate his with ornate and colorful designs usually displayed against a white ground. The times may have been ripe for a shift in taste toward such lavish decoration, but still it took courage on Ninsei's part to lead the way. Another interesting innovation in Ninsei's tea jars is their sur-

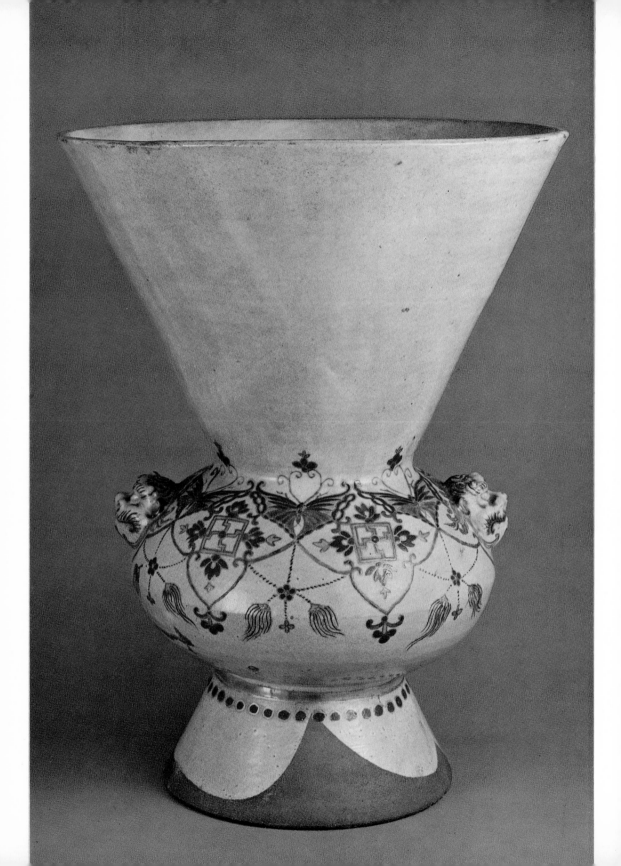

◁ *73. Ninsei: Flower vase with an overglaze design of Buddhist beaded ornaments. Ninsei worked under the sponsorship of the Ninna-ji, and this is one of the finest works he presented to that temple. The vase is unique in its exaggerated, top-heavy proportions, probably based on the shape of a small hand drum. It is also noteworthy for the gentle harmony of colors in its decoration and for the great precision with which the design is executed. Ninna-ji temple, Kyoto.*

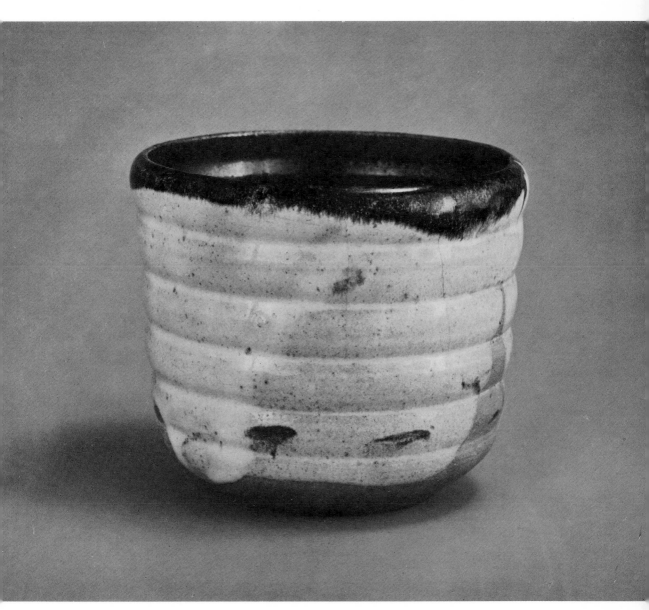

74. Ninsei: Waste-water jar for use in the tea ceremony; straw-ash glaze on Karatsu ware. Manju-in, Kyoto.

75. (Overleaf) Ninsei: Cylindrical water jar with Seto-style glaze. Kyoto City University of Art. ▷

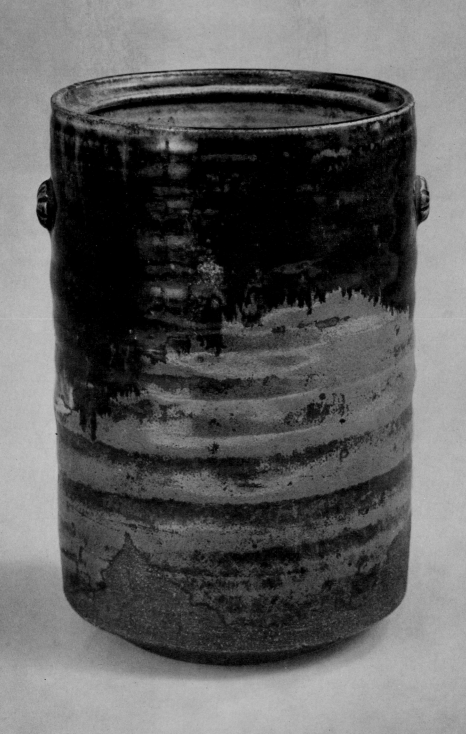

76. Ninsei: Kettle lid rest for tea-ceremony use, in the shape of a wooden spool.

77. Ninsei: Tea-leaf jar decorated with a dragon in overglaze enamel.

prisingly light weight. The jars do not look light in appearance, but clearly Ninsei had consideration for the owner of the jars, who would transport them filled with tea leaves. His own pride as a potter may also have had something to do with his making the tea jars thinner and lighter than usual.

Ninsei's tea-leaf jars are of two types. One is essentially round in shape, like the famous Mt. Yoshino jar (Plate 49), while the other has a noticeable shoulder (Plate 66). A more important distinction involves design. Some jars have tree and flower decorations and others landscape. The floral designs, being essentially decorative, can be easily made to conform to the shape of the jar, regardless of its size. Pictorial landscape, on the other hand, is rather more difficult

to adapt to a round form, providing a challenge to which Ninsei must have devoted much attention and diligent experimentation. On the Mt. Yoshino jar he solved the problem by placing the landscape almost vertically on one quarter of the jar as the focal point, and placing the secondary design of cherry blossom on either side of the central design and on the back of the jar.

Decorative Ability

A study of Ninsei's tea-leaf jars indicates clearly his ability to solve large problems of design, but the variety and skill of his decoration are perhaps even better shown in those pieces that are oddly shaped.

78. Ninsei: Tea bowl with an overglaze-enamel design of clematis. Nezu Art Museum, Tokyo.

The incense box (Plate 46) discussed earlier is a superb example of his decorative abilities, as are nearly every one of his tea bowls. These played an essential role in the tea ceremony, and Ninsei was particularly fond of them for the opportunity they offered to demonstrate his considerable skill.

Plates 67 and 86 illustrate two of Ninsei's outstanding tea bowls. The bowl with a design of a crescent moon rising out of churning waves (Plate 86) is slightly taller than most tea bowls and has a semi-circular cut in its foot. The clay is sandy with a somewhat reddish cast, and the shape was unmistakably inspired by a type of Korean bowl known as *goki* in Japan. Because the natural color of the clay was not suited to overglaze decoration, Ninsei applied a white slip—a coat of fine liquid clay on which the enamels were painted. Against this modified background the reddish-purple of the crescent moon makes a most harmonious contrast. This is one of Ninsei's greatest pieces, revealing immediately how far his skills extended beyond the capabilities of the average potter.

The inscription on the box for this tea bowl reads: "Gift of Sōwa the Elder, Ninna-ji ware." The writer of the inscription was given the bowl by Kanamori Sōwa. Since Sōwa died in 1656, the bowl must have been made earlier; yet, according to tradition, Seiemon did not take on the name Ninsei until 1657, and the bowl is clearly stamped with the latter name. Evidently, tradition is incorrect, and the name Ninsei was adopted sometime earlier. The bowl is of interest as a

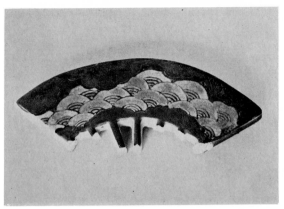

79. Ninsei: Enameled nailhead covers.

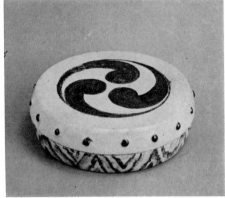

*80. Ninsei: (Left) Enameled incense box in the form of a hen coop. (Right) Incense box in the shape of
a drum with underglaze iron-oxide decoration. Nezu Art Museum, Tokyo.*

clue to the date when Ninsei took his name, but much more so as proof that Ninsei was producing overglaze work of the finest quality by the middle 1650s.

The so-called Musashino tea bowl (Plate 67) is another example of Ninsei's supreme talents as a designer. Its name is derived from the famous grass-covered plain of Musashino to the west of present-day Tokyo, and the autumn-grass decoration of the tea bowl seems to capture the feeling of the area. Much of the bowl's exterior surface is covered with silver glaze, now deeply tarnished. The moon is formed by a section left unglazed, with stalks of grass silhouetted against it. The whole work shows how effectively Ninsei was able to combine a few simple elements into a design of great emotional force.

The famous tea bowl decorated with a design of "fish scales" and waves (Plate 68) is also of great interest. The outer surface is completely covered with a pattern of triangles enclosing smaller triangles, broken only by strong streaks of green glaze flowing in a seemingly accidental rhythm from bottom to top. This sense of randomness was produced by holding the bowl upside down by the foot and pouring glaze over it with a ladle. The unusual overall effect results from the tension between the precise, mechanically repetitious "fish scale" pattern and the free, uncalculated flow of the green-glaze "waves." Kanamori Sōwa, the great tea master, may have inspired the idea for this decoration, but Ninsei was himself perfectly capable of creating the intriguing design. In every

81. *Ninsei: Wall vase in the shape of an icicle; Hagi-style glaze.*

82. *Ninsei: Wall vase in the shape of a scepter; Mishima-style decoration.*

sense, he was a designer of extraordinary imagination and ability.

The exact date of Ninsei's death is not known, but he did leave two sons, Seiemon and Seijirō. The former attempted to carry on the family trade for a time, but he was possessed of little of his father's creative genius. His lack of talent as a potter is borne out by a document recording a commission that came to him in 1695 from the lord of the Maeda family of Kaga through the tea master of the Ura Senke school. The thirteen incense boxes made by Seiemon for Lord Maeda apparently turned out so badly that the tea master serving as intermediary was forced to admit sadly that the second generation was unable to uphold the reputation of the illustrious Ninsei.

7

Ogata Kenzan

Ninsei's sons were unable to maintain the standards of excellence set by their distinguished father. There was, however, a potter in Kyoto who could take the place of Ninsei's untalented offspring and not only rival their father but also give new impetus and direction to Kyō ware. His name was Ogata Kenzan (although he had been born Ogata Gompei and had changed his name first to Shinsei before finally taking the name Kenzan). Born in Kyoto in 1663, he was the third son of Ogata Sōken and member of a family that had been clothiers for generations. The Ogata shop, called Kariganeya, was a large and well-established business, catering mainly to members of the imperial family and the Kyoto aristocracy. Kenzan grew up in cultured surroundings, amid rich and finely decorated textiles, and enjoying the acquaintance of

some of Kyoto's finest artists and craftsmen. His great-grandfather had married a sister of Hon'ami Kōetsu, the great amateur artist-craftsman who had provided much of the inspiration for an important renaissance of classical Japanese arts. The Ogata family was also indirectly related to Tawaraya Sōtatsu, an associate of Kōetsu's and an influential painter of the early seventeenth century. Kenzan's elder brother Kōrin was also a distinguished painter and founder of what has come to be known as the Rimpa school of painting, which sought inspiration in earlier, purely Japanese art forms. For an artist, Kenzan's background was ideal.

His talents, however, were slow to develop. Unlike his extroverted brother Kōrin, Kenzan was shy, quiet, and scholarly. He particularly enjoyed Japanese and Chinese poetry, as well as the writings of con-

83. *Kenzan: Three rectangular plates with overglaze-enamel wave designs. Note signature on reverse of plate at left. Nezu Art Museum, Tokyo.*

temporary poets, which in the years ahead would provide him with the quotations that he wrote on much of his pottery. His youth was spent largely in the art colony of Takagamine, which had been founded by Kōetsu. There he was given by Kōetsu's grandson Kōho the secret pottery notes of Kōetsu himself. These notes stimulated his interest in ceramics, as did his study of Raku ceramics under Ichinyū, head of the fourth generation of Raku makers.

Shortly after his father's death in 1687, Kenzan built near Ninsei's Omuro kiln a retreat that he called Shūseidō. There he planned to live the life of a studious recluse, but its proximity to Omuro revived his early interest in pottery. Undoubtedly he had known Ninsei since childhood, but there is no record of his

actually studying under the great potter. In any case, in 1699 Kenzan forsook his retreat and established a kiln at Narutaki-Izumidani on land provided by Lord Nijō Tsunahira. The kiln lay in the hills, a mile and a half west of Omuro, and was in those days quite remote from the bustling capital. Kenzan took as assistants Ninsei's son Seiemon and Magobei, a potter who made Oshikōji ware. Ninsei's younger son Seijirō made a present to Kenzan of his father's *densho*, an invaluable record of information about pottery compiled over the course of his career by Ninsei. Kenzan apparently did not set up his kiln as merely a random gesture by a wealthy dilettante. He was thirty-seven when he moved to Narutaki, old enough to begin a new career in ceramics, but he had behind him a

84. Kenzan: Star-shaped overglaze-enamel bowl with an auspicious ideogram in the interior. One of a series of pieces Kenzan made at Sano, north of Tokyo.

cultured background, a feeling for pottery, and a highly cultivated eye for design.

Narutaki lies to the northwest of Kyoto, a direction labeled in classical Japanese *inui,* and Kenzan named his type of pottery *Inuiyama* ("northwest mountain"). Pronounced with alternate readings, the same ideograms become *Kenzan.* This was the name he gave his workshop and later took as his own art name. At that time his brother Kōrin was able to join in the activities of the kiln, and the two often collaborated on single pieces. One such joint effort is the square dish illustrated in Plate 99. Kenzan produced the plate itself, Kōrin painted the old plum branch, a favorite theme, and added his signature. Finally, Kenzan added in the remaining space at the upper right one of his favorite

poems and signed his own name. Kenzan took great pride in his brother's collaboration and at times humbly included the statement "My copy of brother Kōrin's design."

Once established as a potter at Narutaki, Kenzan worked happily and diligently at his new career. He had inherited some wealth from his father, but his insatiable desire to experiment with new materials and methods quickly consumed this legacy. By 1712 he was forced by financial difficulties to abandon the Narutaki kiln and move back to the capital. There he opened a shop and began to make and sell ceramics commercially. Most likely, he rented space in one of the Kiyomizu kilns for firing and sold the finished products in his own shop. The pieces made during this

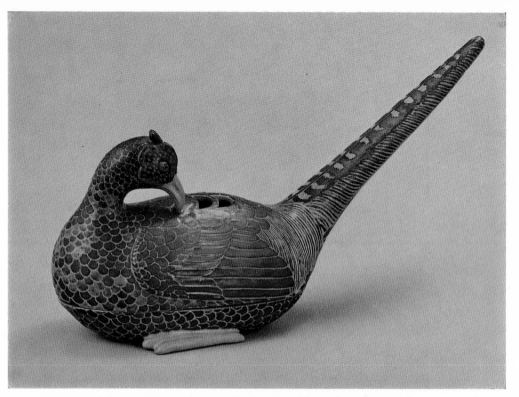

85. *Ninsei: Enameled incense burner in the shape of a pheasant. Although this piece was made as an incense burner, it is almost too large to be functional and might better be considered a sculptural decorative object. Except for the coloring of the pheasant's head, the colors are limited to varying light and dark shades of silver.*

86. *Ninsei: Tea bowl with design of a crescent moon riding the waves. Unlike most of Ninsei's tea bowls, this one* ▷ *has the slender, regular shape and divided base of a type of Korean bowl known in Japanese as goki. Ninsei's individual touch can be recognized in the use of a white slip over the reddish body to provide a harmonious background for the maroon of the new moon and the blue waves. Tokyo National Museum.*

87. Kōrin and Kenzan: Tea bowl with an iron-oxide design of a blossoming plum tree.

88. Kenzan: Water jar with eggplants in iron oxide. ▷

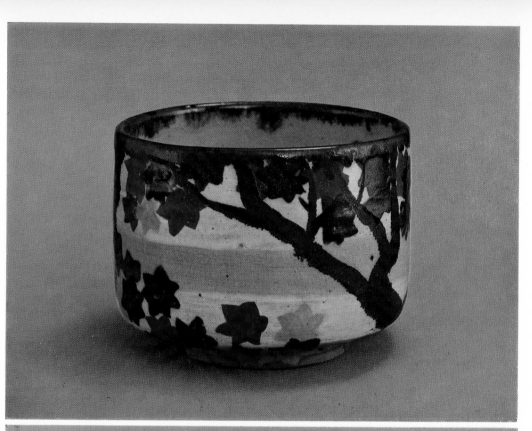

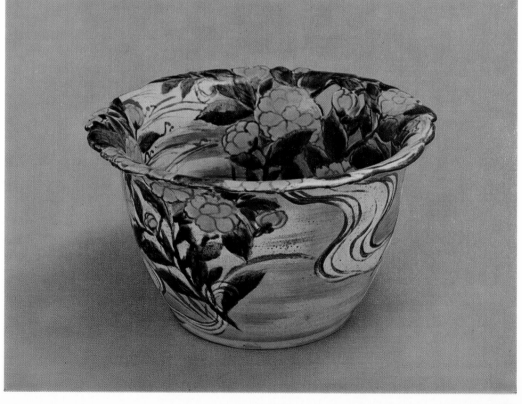

◁ 89. Kenzan: Tea bowl with enamel-overglaze decoration of maple trees along the Tatsutagawa river. Most of Kenzan's color designs were covered by a low-fired transparent Raku glaze, but here the enamel colors were painted over the glaze. The bands of clouds were painted first on the bare clay in white glaze, together with the tree trunk in iron oxide and certain of the leaves in a mixture of iron-oxide and cobalt-blue glazes. After a first firing, red, yellow, and green glazes were applied and the cup was refired. Enshō-ji temple, Nara Prefecture.

◁ 90. (Below) Kenzan: Openwork bowl with a design of yamabuki (yellow kerria flowers) along the Tamagawa river. Eddies painted in iron oxide over a white slip suggest the rapid flow of the river. The flowers along its banks are painted in thick green and yellow enamels. Close to the rim are sections of openwork following the outlines of leaves and flowers, a technique uncommon in Kenzan's work.

91. Kenzan: Pair of boat-shaped dishes. Although the clay used is not as dark as earthenware pottery, the decoration is handled as though it were: a white slip is used as background for the overpainting done in blue and brown. On the dish on the right, the slip represents a mountain in spring; on the other dish, it simulates snow on bamboo. Nezu Art Museum, Tokyo.

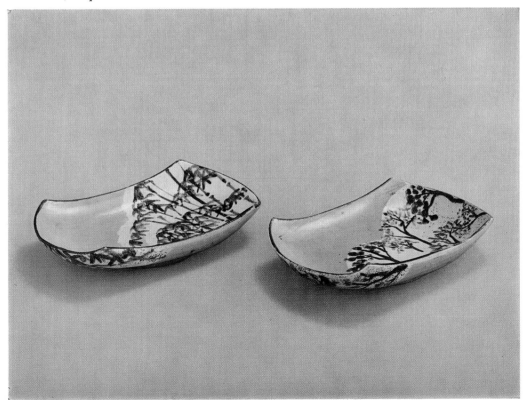

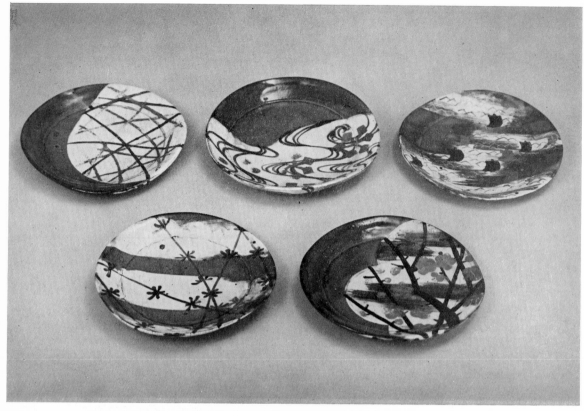

92. Kenzan: Set of five earthenware plates with overglaze-enamel decoration. Nezu Art Museum, Tokyo.

period are not among his best; they were produced quickly and in quantity, and while they did provide him with a meager living, they did not satisfy his creative urge. Some of Kenzan's work of this period shows great talent and originality, but most is routine, lacking strength and character.

To add to his burdens, Kenzan's supporters fell from influence, and his brother Kōrin, after a series of difficulties with authorities for his flaunting of the strict sumptuary laws of the time, died in 1716. Dispirited and in straitened financial circumstances, Kenzan welcomed an offer to move to Edo around 1731. His new patron was Prince Kimihiro, a priest at the Rinnō-ji temple, who provided a house at Iriya on land owned by the Kan'ei-ji temple. Although nearly seventy years old, Kenzan faced life with renewed

energy and threw himself into making pottery, reading, and painting until his death in 1743 at the age of eighty-one. His life had not always been easy, but it had been a rewarding one: He was known as a literary scholar, a skilled painter and calligrapher, and above all a master ceramist. Inspired by Kōetsu and Sōtatsu, he had been able to translate into ceramics the creativity they had brought to painting and calligraphy. His greatest contribution to the development of Japanese art was the elevation of ceramics from a craft to an art.

Kenzan's Work

Kenzan produced a wide variety of pieces, among them a large number of square dishes with iron-oxide

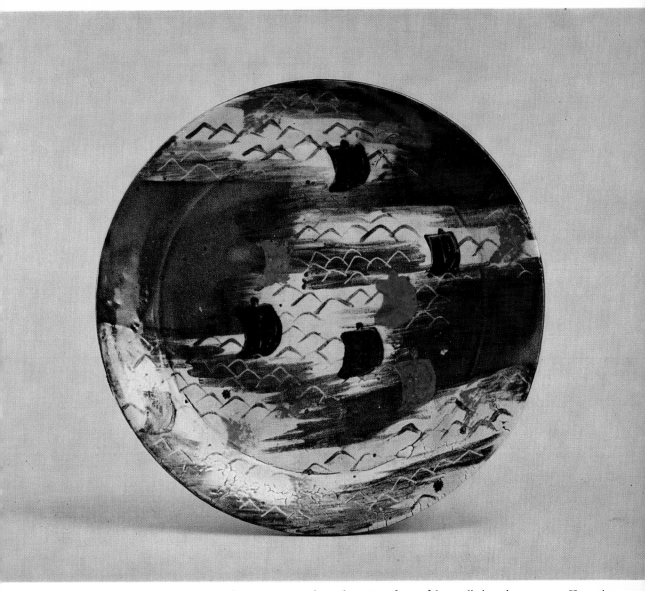

93. *Kenzan: Earthenware plate with seascape decoration in enamel overglaze. One of a set of five small plates that are among Kenzan's best-known works (see also Plate 92). On purplish-brown clay, white slip forms a ground for the sails and the outlines of waves, which were either painted directly on the slip or scraped through a coat of blue to reveal the white slip beneath. Early eighteenth century. Nezu Art Museum, Tokyo.*

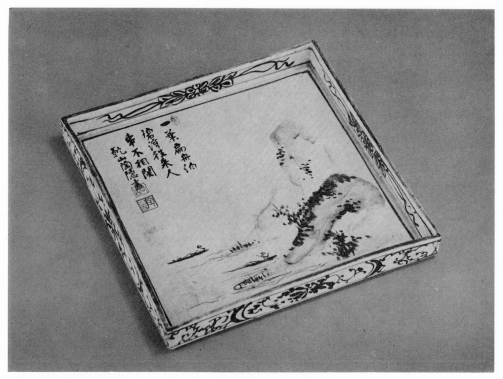

94. *Kenzan: Square plate with a landscape drawn in iron oxide, illustrating the poem at the upper left. Nezu Art Museum, Tokyo.*

decoration like that in Plate 99. The square shape, with its flat inner surface, was well suited to decoration with pictorial images and with calligraphy. It was also particularly well suited to the decorative skills of his brother Kōrin, who was untrained in the problems of painting on a three-dimensional ceramic surface. Kenzan, too, seems to have preferred this shape, for his forte lay more in the painter's world of drawing and calligraphy than in the potter's realm of turning and molding. These square plates, framed by low sides, were a new concept and one ideally suited to pictures and writing. Kenzan disproved the tradition that ceramics had to be strictly utilitarian by treating them as works of art in their own right, a concept that the average potter of the day could hardly comprehend. In order to emphasize the individuality of his own

work, Kenzan rarely used impressed seals, choosing instead to write his signature with a brush.

Plates 94 and 95 show two square dishes decorated in the manner of small landscape scrolls. The flat interior of each, after careful smoothing, was covered with a white slip, which served as a ground for the painting. As the last step a transparent Raku glaze was applied, and the piece was fired at a low temperature. Although the painting was done in underglaze iron oxide, Kenzan's pieces, unlike most Kyō ware using this method of decoration, were fired at the low temperature of Raku ware—somewhere between 700 and 900 degrees centigrade. There appear to be several good reasons for this: at higher temperatures, the large thin bottoms of the dishes tended to warp or crack, or the overglaze was likely to run or change color.

95. Kenzan: Square plate with a lone fisherman drawn in iron oxide, illustrating the poem at the upper left. Nezu Art Museum, Tokyo.

Kenzan's assistant Magobei, being a maker of Oshikōji ware, was familiar with Raku techniques and could advise on the problems of firing. With his help Kenzan devised a new process that might be called underglaze enamel Raku ware, in contrast to the over-glaze enamel high-fired ware normally made by Kyoto potters. The painting was done directly on the clay body with Kōchi-style color glazes, which were then covered with a transparent glaze and finally fired under a low heat. The most highly colored examples of Kenzan's work were probably done by this method, and because they were made of Raku-type clay, they are lighter than overglaze pottery and thus more con-venient for everyday use. Another advantage of Kenzan's method is that colors placed under rather than over the glaze seem glossier and more intense.

Kenzan used this technique of color glazing on square plaques similar to the dishes and also on such varied pieces as the bowl illustrated in Plate 96 and the ewer in Plate 100. The latter has a curiously elongated shape, copied perhaps from Oribe-ware pouring vessels. The body is covered with a white slip and the background colored a dark green with purple plum branches. The blossoms and the clouds are merely the white slip with certain details added. All was covered by a thin coat of transparent glaze. The glossy design, basically one of stripes and circles, is new and exciting, quite unlike anything conceived previously by the potters of Kyoto.

The bowl in Plate 96 combines harmoniously both shape and design and illustrates once again Kenzan's individual touch. The shape is like a mass of brightly

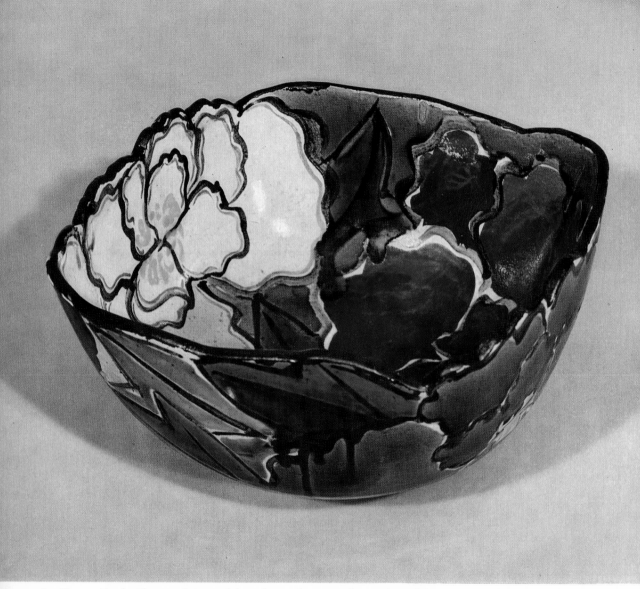

96. *Kenzan: Bowl with peony design. While working at his Nijō Chōji-machi workshop, Kenzan catered to popular demand for ceramics with bright, colorful decoration. Most such pieces lack inspiration, but this one is an exception and reveals Kenzan at his best. To enhance the impact of the strong, solid colors, he incised the outlines of the peonies, making the design stand out in low relief.*

97. *(Above) Kenzan: Red Raku tea bowl with a design of plum blossoms. Kenzan's earliest ceramic training was in Raku ware* ▷
and he was skilled in its techniques. Red Raku pieces are rather rare, especially ones like this with fine pictorial decoration. The bowl itself bears no seal, but is identified as Kenzan's by his signature on its box. Kyoto City University of Art.

98. *Kenzan: Square box with lid, decorated with pine trees and waves in both underglaze and overglaze. This container was ap-* ▷
parently made from flat slabs of clay gently shaped into the present form. The pine motif was initially done in kaolin and asbolite under-glaze, with overglaze gold and silver pines later superimposed. The inner surfaces of the box and lid are in white slip and asbolite under-glaze with additional gold-colored waves in overglaze.

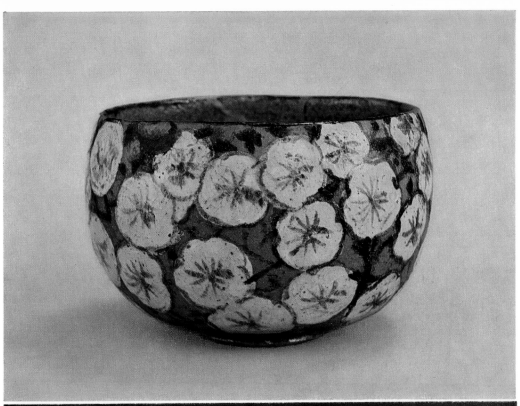

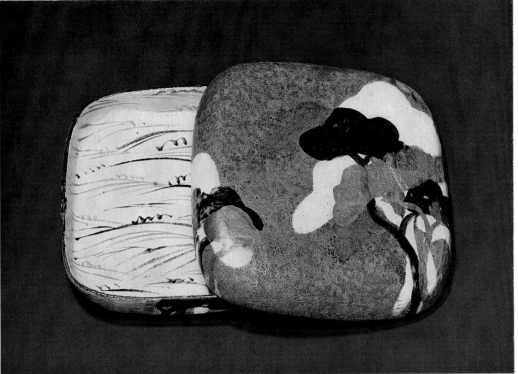

99. *Kōrin and Kenzan: Square plate with an iron-oxide design of a blossoming plum tree illustrating the poem in the upper right-hand corner. Nezu Art Museum, Tokyo.*

100. *Kenzan: Enameled water ewer with plum-blossom decoration. Kyoto City University of Art.* ▷

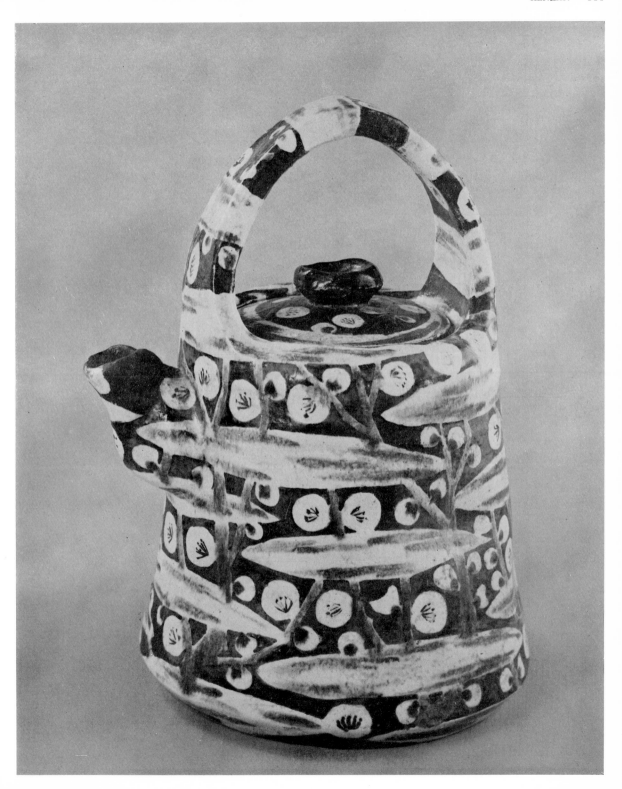

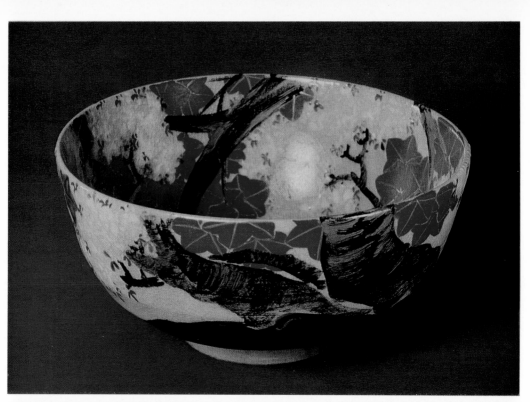

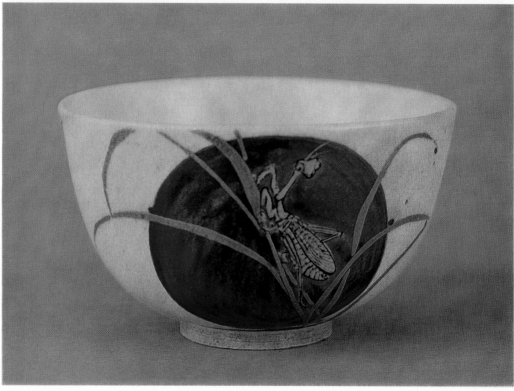

◁ *101. Nin'ami Dōhachi: Bowl with overglaze-enamel decoration of maple trees and cherry blossoms. Dō-hachi, active in the mid-nineteenth century, was a leading Kyō-ware craftsman, and this is one of his finest pieces. His decorative style is clearly descended from Kenzan and the painters of the Rimpa school. Here he boldly mixes spring and autumn motifs in a strong and colorful design. Tokyo National Museum.*

◁ *102. (Below) Eiraku Hozen: Tea bowl with overglaze-enamel decoration of moon and praying mantis. Hozen was a late Kyō-ware potter known for his skillful imitations of earlier Kyoto ceramics, including the works of Ninsei. On this piece, the powerful contrast of the mantis against the moon suggests a boldness of design surpassing even Ninsei's. Tokyo National Museum.*

103. Kenzan: Brush holder with overglaze-enamel decoration of children and flowers.

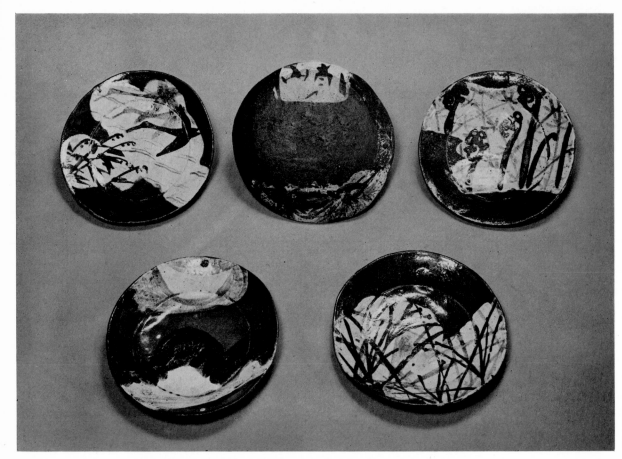

104. Kenzan: Set of five earthenware plates with overglaze-enamel decoration.

colored peony flowers and leaves with the irregular outline of the flowers carried by the line of the rim. The effect is casual and yet highly forceful in its use of strongly contrasting tones. This particular style was often copied in later years by the Kyoto potter Dōhachi (1783–1855), but never was he able to achieve quite the force of Kenzan's impact.

Kenzan's Technique

Kenzan's use of a white slip is worthy of consideration in detail. As the square dishes show, a smooth white ground is best for painting and calligraphy. Not satisfied with the color of the clay body, Kenzan searched for a finely textured white clay that could be applied in liquid form, and he eventually found it at Akaiwa in northeast Kyūshū. Painting in black over a white ground was a Chinese technique used on Tz'ŭ Chou ware, and examples in the form of tea bowls had found their way to Japan. Kenzan eagerly adopted the idea and used it with startling effectiveness, as illustrated by the large bowl in Plate 108. The painted signature on the bottom shows that the bowl was made while Kenzan was still living in Kyoto. In the center of the bowl is inscribed a tale by the Sung-dynasty scholar-official Ssu-ma Kuang, and around the edges and on the outer surfaces are illustrations related to the story. There is no color, but the bowl is notable as one of Kenzan's finest compositions.

Kenzan did not use white slip exclusively as background. At times he used it to make a contrast with the natural color of the clay, as exemplified in two sets of small dishes (Plates 92, 93, and 104). A section of each plate was coated with slip, over which designs

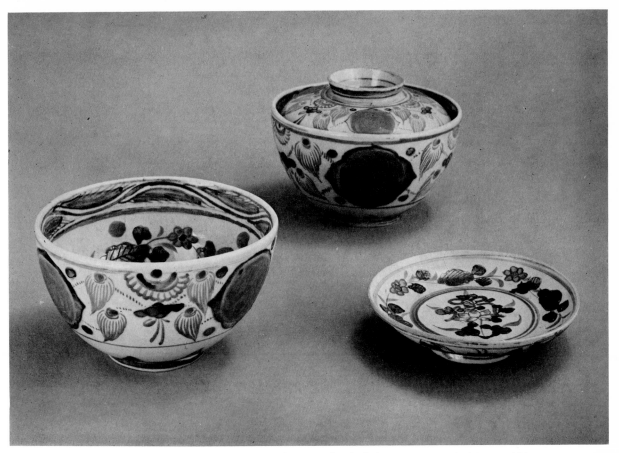

105. Kenzan: Covered bowls with overglaze enamel and gilt decoration. Nezu Art Museum, Tokyo.

were painted. The areas of slip vary according to the type of design, but they always stand out strongly against the dark natural tone of the clay. This type of decoration is characteristic of Kōrin's so-called Rimpa school of painting. As the illustrations reveal, the drawing, unlike that of Ninsei and other Kyō-ware decorators, is neither precise nor detailed. Rather, it is quick, free, and impressionistic, inaugurating a whole new style of ceramic ornamentation. Although the technique was imitated by lesser potters, only Kenzan had the flair to handle so unconventional an approach with total success.

Another technique used by Kenzan was that of overglaze porcelain. As mentioned earlier, Kyō enamel ware differs from the Arita wares in that the overglaze was applied to pottery rather than to porcelain. Kenzan experimented with the making of porcelain in his attempts to copy Chinese wares. In his own personal notes he tells of mixing Hira clay from Omi Province east of Kyoto with his fine white slip clay from Kyūshū in order to obtain the necessary ingredients for his copies of Chinese types of porcelain. The two bowls in Plate 105 are examples of the resulting product, and on their box Kenzan wrote: "Copied from Chinese ware." They are of rather heavy white porcelain with underglaze blue and overglaze red decoration—quite different from the pieces done with the low-fired underglaze color technique described earlier. Plate 103 illustrates a copy of a Chinese piece of the early Ming dynasty, but in this case the body is not a true porcelain; it was necessary here to paint the decoration over white slip. Curiosity, knowledge, and a sensitive eye allowed Kenzan to appreciate the best qualities in a wide variety of ceramics—Chinese, Japanese, and

106. *Kenzan: Decorated tea bowl called Takisansui (Waterfall Landscape). One of the several such bowls to which Kenzan added a poem, usually on the reverse side.*

107. *Kenzan: Six triangular serving vessels with plum design, called* ▷ *Yarиume (Spear Plum). The background is a vivid dark green color; the trunks and branches, a blackish-brown iron oxide; and the plum blossoms, a white glaze. The base of one of the vessels shows Kenzan's signature. It is a beautifully executed design, reflecting in full measure Kenzan's skill. Height, 6.5 cm; diameter, 8.5 cm.*

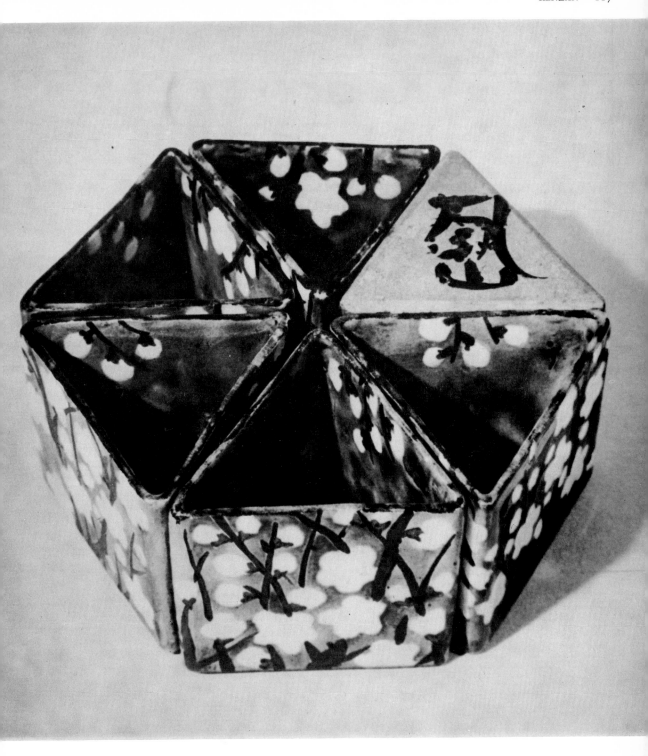

108. *Kenzan: Large bowl with decoration in the Chinese Tz'ŭ Chou style.*

even Dutch, for there is reason to believe that he had the opportunity to examine ceramics brought from Europe by Dutch traders.

In his youth Kenzan studied Raku ware under Ichinyū, and although he did not make many tea bowls of Raku, those he did make were of very high quality. Plate 97 illustrates a recently discovered red Raku bowl made, as was the custom, by hand rather than on a wheel. It curves in slightly at the top, and its shape is hardly different from bowls produced by Dōnyū (1599–1656), the third-generation Raku master, or by Ichinyū. For Kenzan, however, the shape was merely the starting point for the finished object. Using his favorite white slip, he scattered plum blossoms linked by dark twigs across the outer surface of the bowl,

thus creating one of the first examples of fully decorated Raku ware. Dōnyū had made a black Raku bowl with a white design covering only a small part of its surface, but a bowl as colorfully and fully decorated as Kenzan's must have startled his contemporaries. Perhaps in deference to the Raku makers he did not sign the bowl, only the box. In any case, no signature was necessary; a single glance at the flair displayed on this bowl is enough to identify its maker.

Kenzan had many followers, chief among them his adopted son Ihachi, Miyazaki Kenzan (who called himself Kenzan III), and Miura Ken'ya. All were technically skilled, accomplished potters, but none could recapture Kenzan's unique spirit and flair. Ninsei could be copied; Kenzan could not.

8

Latter-day Kyoto Ceramics

Kenzan died in 1743, almost exactly the midpoint of the Edo period and of Kyō-ware production as well. By then practically all the characteristic techniques of turning, shaping, and decorating had been developed and were being widely practiced: iron-oxide and cobalt underglaze, overglaze enamels, Kōchi and Raku color glazes, imperial Kyō wares from official kilns, porcelains in the Chinese styles, and copies of Dutch pottery. The only ware not made in Kyoto was celadon, a high-fired ware with a soft blue-green glaze. After Kenzan's death there were no significant innovations in Kyō ware, only variations of tested familiar themes and techniques. But although such variations could not claim strong originality, they were by no means always routine or uninspired.

The changes that did occur in ceramics and in other arts during the latter half of the Edo period were the results of changing tastes. Painters such as Ike no Taiga (1723–76), Uragami Gyokudō (1745–1820), and other members of the so-called Nanga or Southern school of painting became popular. This school took its inspiration from the style evolved by Chinese scholar-painters of the seventeenth and eighteenth centuries and brought with it a taste for Chinese literature. The traditional form of the Japanese tea ceremony, which used powdered tea, was for a time superseded by the Ming-dynasty version, using steeped tea. Such influences affected the world of Japanese pottery as well, creating a demand for writing implements and tea utensils in the Chinese style.

109. *Nin'ami: Early Kiyomizu-ware flower vase in the shape of a gold-dust bag.*

110. Eisen: Container for coals for braziers; decoration in overglaze enamel of flowers and birds. Daichū-in temple, Kyoto.

Okuda Eisen (1753–1811) was the first potter to cater to the new taste. He produced fine underglaze blue-and-white and overglaze enamel porcelain in the style of late Ming and early Ch'ing wares (Plate 110); he also did beautiful copies of Kōchi ware from South China. Among his many talented students were the famous Nanga painter Aoki Mokubei (1767–1833), who was equally proficient at making celadon, enamel ware, and pottery in the Kōchi style. Nin'ami Dōhachi (1783–1855) carried the art of making purely Japanese Kyō ware, best represented by Ninsei and Kenzan, to its final peak of refinement (Plates 101 and 109). Eiraku Hozen (1795–1854), originally a maker of pottery braziers for use in the tea ceremony, specialized in Kōchi glazes and developed subtle colors which became one of the distinctive features of later Kyō ware (Plate 102). In addition to these potters and other less distinguished makers of Kyō wares, there were potters in Kyoto who did not follow the Kyō traditions, and hence are better treated elsewhere.

Although the potters of Kyoto have never ceased to produce fine pottery, it is clear that the creative impulse behind their work had lost its energy by the latter half of the eighteenth century. Later Kyō ware tended to be imitative of the masterpieces of the earlier period, weak variations of the superb models of the past. The technical skills of such masters as Ninsei and Kenzan could be matched by lesser potters of succeeding generations, but never their untrammeled inventiveness or creative genius.

9

Authenticating Kyō Ware

In previous chapters, some of the difficulties of recognizing Kyō ware were discussed. Even today, the exact appearance of Oshikōji ware and of the tea caddies and bowls that came to Japan from Korea is largely conjectural. It is also not always possible to differentiate between the Rihei enamel ware made in Takamatsu and that of Kyoto. Nor can a precise distinction always be made between examples of Seikan-ji, Yasaka, and Mizoro wares. Some wares survive in name only, with no extant examples to give a clue to their actual appearance, others are from known kilns but cannot be dated, while still others cannot be associated with any particular kiln. Such problems reveal clearly that our present knowledge of Kyō ware is still far from perfect or complete.

Despite such deficiencies, however, it is still important to consider the question of authenticity. Not unexpectedly, Kyoto ceramics have often been faked and at times extremely well faked. Since imitations are always made for profit, it is quite natural that only the most popular pieces or styles were copied. Genuine Kyō pieces from recognized kilns but not attributable to any individual artist have never brought high prices on the art market, and few attempts have been made to copy them. The only exceptions are the so-called export ceramics that became popular abroad after the start of the Meiji era. Such pieces try to recapture the elaborate style illustrated by the extraordinary hand-warmer illustrated in Plate 15. Some of these imitations were done by highly skilled potters using the

same clay, glaze, and enamels as the originals and are almost indistinguishable from authentic pieces. Their only fault, almost inevitably the sin of the forger, is a lack of restraint, a tendency to overdo or to exaggerate what is being copied: These pieces exhibit too much intricate openwork, too many colors, too much crowding of design. Or else they may overstress the decorative role of the designs and sacrifice the harmonious balance between shape and decoration that characterizes the finest Kyō ware.

It is always necessary to examine the surfaces of colored enamels with great care in order to authenticate them. Enamels are softer than high-temperature glazes, and over the years they tend to wear and show scratches. This is particularly true of gold glaze, which is so soft that whole areas can disappear entirely. If an overglaze piece represented as Kyō ware has a smooth surface, it should be regarded with the greatest caution and suspicion. In contrast to enamel wares, underglaze iron-oxide and cobalt pieces are more rarely imitated, perhaps because they are of more subdued character and less popular appeal.

The works of Ninsei and Kenzan are by far the most widely copied, with Ninsei's taking the lead. At the end of the Edo period, there was hardly a shop in the Kiyomizu district of Kyoto that did not have a Ninsei stamp, for at that time he was considered the unimpeachable master of Kyoto pottery. Initially these copies may have been made by young apprentices as a learning technique in order to gain experience, but as their quality improved it became impossible to resist the temptation to add a Ninsei stamp and pass off the imitation as an authentic piece.

Copies of Ninsei's larger pieces with sizable stamps are scarce because they were difficult to make and their designs hard to imitate convincingly. Small pieces, however, with little stamps, some with parted curtains at the top of the seal, are quite common. Ninsei used a variety of stamps: large size, small size, with border, without border, with curtains at top, without curtains. So many variations occur that it becomes well-nigh impossible to determine absolutely which are genuine. When the same stamp is applied to unfired clay, the impressions are not always identical. Much depends upon the quality of the clay and the temperature of the subsequent firing. Consequently, it is just as dangerous to base a judgment on pottery stamps as it is to depend on the seals to determine the authenticity of Oriental paintings.

False stamps were easy to make and many potters used them, a fact that makes it pointless to judge a work attributed to Ninsei by its stamp alone. It has been said that Ninsei always impressed his seal on the left side of the bottom of every piece he produced, but not all his seals are so placed. Some are indeed on the left, but some appear on the right or in the center. On the whole, Ninsei stamps tend to muddy rather than clarify the problem of authentification.

Is it possible to recognize a copy in every case? At one time this writer suspected that pieces turned clockwise on a Seto-type wheel could not possibly have been made by Ninsei, but this theory has not held up. Except for those of obviously inferior quality, there is no practical method yet devised to detect skillful imitations.

As mentioned earlier, the essence of Ninsei's art lies in his extraordinary skill in shaping and in pictorial decoration. These are the points to look for, and one's search will be aided immeasurably by an eye trained through careful study of Ninsei's authenticated masterpieces. In general, fakes can be divided into two groups: copies of originals and variations on originals. The best pieces are so well known that it would be absurd to attempt to pass off copies of them as authentic. Ninsei's imposing pheasant (Plate 85) or his tea-leaf jar decorated with a scene of mountain temples (Plate 66) are so famous and are in known collections, so that copies would be immediately recognized as such. Even if copies were made, the stiff and hesitant brushwork that characterizes such attempts would give them away.

Far more common are fakes in the style of Ninsei, pieces that differ in some way from acknowledged originals but are similar enough to be very difficult to detect. The best approach to decide whether such a piece is genuine or not is to try to seek in its design the freedom and sensitivity of Ninsei's hand. A trained and perceptive eye can see in a particular design that the master probably would have left more empty space or that the type of design is not well enough suited to the shape of the piece. When one recalls how very carefully Ninsei worked out the balance between

shape and design, this process of detection is actually not as difficult as it may sound.

As is true of early Kyō ware, Ninsei's more colorful pieces are the most popular and consequently the most imitated. There are not many copies of his simpler pieces with Seto glaze or those done in the manner of Karatsu, Agano, or Shigaraki ware.

Many of the boxes containing Ninsei's works are thought to bear the signature of Kanamori Sōwa, the distinguished tea master. Sōwa, being his chief patron, had a strong influence on Ninsei's ceramic designs, and if Sōwa signed a box, it usually indicated his approval. Signed boxes are not in themselves adequate proof of authenticity; the contents of some boxes have been switched or Sōwa's signature has sometimes been forged.

The style of calligraphy, suitability of the box, and above all its contents must be studied with the greatest care before a verdict is passed regarding authenticity. If all pass muster, Sōwa's signature may be the final determining factor in the verification of a piece.

As can be imagined, Kenzan's works are equally difficult to authenticate. There are in existence more copies than originals. Kenzan's work can also be divided into two general categories, the first of which is rarely copied. This first group consists of pieces made to satisfy Kenzan's own creative urge. A good example might be the large bowl illustrated in Plate 108, a piece noted for Kenzan's spirited drawing and sensitive calligraphy; clearly, it would lie far beyond the talents of the average forger to attempt an imitation of a piece like this. Moreover, the black-and-white drawing on this first group of pieces lacks the popular appeal of Kenzan's colored wares, and consequently there would be little reason to copy them. The same lack of widespread appeal may also account for the fact that there are virtually no copies of the square dishes that Kenzan made in collaboration with his brother Kōrin.

The second group consists of Kenzan's colored wares, made commercially at the Nijō shop in Kyoto. These were made to appeal to popular taste rather than to the artist's own, and they tend to be brightly decorated, sometimes even to the point of excess. Since, even today, these pieces are extraordinarily popular and bring high prices, fakes abound.

Because quantity production was necessary, Kenzan could not make each piece with his own hands. It seems probable that he supervised and signed the pieces, but left the actual painting of some of them to assistants. Even the signatures themselves may have been written by his assistants, meaning that many of the pieces produced at Nijō were not actually made by Kenzan himself. Although his style is difficult to copy, well-trained assistants experienced at working with him could have made good imitations. This possibility introduces the additional problem of trying to distinguish between the works of the master and those of his pupils.

The rectangular dishes shown in Plate 83 and the Oribe-style ewer illustrated in Plate 100 probably belong to the Nijō period. Some of the many pieces now thought to be authentic may well turn out to be copies of works produced at that time. Toward the end of the Edo period, there appeared many pieces made by potters with sufficient skill to imitate the Nijō products, and unless works from that period bear Kenzan's genuine signature, it is well-nigh impossible to distinguish the authentic from the spurious.

It would seem logical to conclude, then, that Kenzan's signature should be the deciding factor. The problem is, however, that Kenzan's assistants also seem to have used it. Kenzan's artistic signature, unlike a painter's, has a decorative style that gives it the quality of a trademark, and it is thus quite different from his ordinary signature and easier to forge. It has been reported by a friend of this writer that he once knew a potter who specialized in Kenzan copies and whose imitations of the signature were so skillful that they could not be told from the original. In view of these facts, it is unreasonable to depend on Kenzan's signature as the deciding factor in determining the authenticity of a piece.

Again, the most reliable way of selecting authentic pieces in the second group is a rather risky process of elimination. The most promising examples should be selected and used as a norm against which to measure and compare other examples. This is a task for future experts, and an exceedingly difficult one because there is no assurance that time will produce more clearly defined guidelines. Perhaps at the present time the best solution, if not the only realistic one, is to accept the

fact that some Kenzan pieces may indeed be forgeries, but forgeries so good that they have almost attained the artistic level of originals made by the hand of the master.

Kenzan had an adopted son Ihachi (actually, the real son of Ninsei) and has also had successors in later generations to carry on his name, although they were not true blood descendants. All made pottery in the Kenzan style, but Ihachi came closest to capturing its spirit, undoubtedly because he worked closely with his adoptive father, beginning at the time Kenzan established the Narutaki kiln. Ihachi must have made many of the pieces produced at the Nijō shop, but it is impossible to point to his work with total assurance.

Ihachi continued to make pottery near the Shōgo-in after Kenzan moved to Edo. Once separated from the supervision of his father, he developed his own recognizable style. There is still to be found around the Shōgo-in and elsewhere pottery in the general style of Kenzan but bearing Ihachi's stamp or his signature on the box. Once the eye grows accustomed to his personal variations, it is also possible to ascertain which of the unmarked pieces are Ihachi's.

In comparison to the work of Kenzan, Ihachi's work seems uninspired and weak. Although pleasantly shaped and delicate in design, his pieces lack the flair and personal force with which Kenzan endowed his work. The same is true of much of the pottery made by Kenzan's successors, and this fact emphasizes once again the tremendous creative energy and talent Kenzan possessed. His successors took pride in joining the line of succession. They did not attempt to copy the Kenzan style exactly, as did his imitators and forgers, but sought rather to create a style of their own that continued to be in the spirit of Kenzan I. In general, this makes their work somewhat more easily distinguished from Kenzan's than that of the imitators, even when unmarked.

Imitations of Kenzan have been made continuously from his lifetime to the present day. As mentioned earlier, there are extremely skillful forgeries of pieces dating from the Nijō years that still await detection. The only forgeries that are relatively easy to recognize are the square dishes with designs in color and calligraphy in black. In these, the coloring is poor and the calligraphy sloppy. If the strength of Kenzan's brushwork and the individual style of his calligraphy are studied carefully and kept constantly in mind, there is less chance of being deceived by the myriad of imitations.

Glossary

Agano: a type of pottery made at Agano in northern Kyūshū by Korean potters captured during Hideyoshi's invasions of Korea in the late sixteenth century. This creamy straw-ash glaze inspired Ninsei to experiment with a similar type of glaze; one of Kobori Enshū's "Seven Kilns."

Arita: the general name given to the ceramics, usually porcelain, made in or near the town of Arita in Kyūshū. The earliest underglaze blue decoration was made at Arita in the early seventeenth century, and it was there that Kakiemon I perfected his enamel overglaze for porcelain in the 1640s. As Arita ware was shipped from the nearby port of Imari, it came to be known also as Imari ware. Nabeshima and Kakiemon wares are also often categorized as Arita ware.

Bizen: a native Japanese type of pottery made initially for everyday use in the Bizen area of present-day Okayama Prefecture. Bizen is designated as one of the "Six Ancient Kilns" of medieval Japan. The clay employed is relatively fine, and the body is hard, dark gray or reddish brown, usually unglazed but sometimes with an unintentional wood-ash glaze. Bizen ware was popular in the tea ceremony and appears in a wide variety of shapes.

Furuta Oribe (1544–1615): a feudal lord and noted tea master who served under Nobunaga, Hideyoshi, and Ieyasu. He was a disciple of Sen no Rikyū, but less austere in his aesthetic outlook. In tea-ceremony ceramics he favored originality, exotic shapes and strong, personal designs. Accused of treason, he was forced to commit suicide in 1615.

goki: the Japanese name for a type of Korean bowl with a slim body and high foot made during the early Yi dynasty (1392–1910). These bowls caught the fancy of Japanese tea masters and were copied in Japan for use in the tea ceremony early in the seventeenth century.

Hagi: a type of pottery made at Hagi in western Honshū by Korean potters from the early seventeenth century on. An opaque milk-white glaze with a marked crackle is characteristic of this pottery, and most early Hagi pieces made specifically for the tea ceremony retain a strong Korean flavor.

Imari: see *Arita.*

irabo: a type of Korean bowl made of rather coarse clay and covered with a yellowish glaze. Like the Korean bowls known in Japan as *goki,* the *irabo* bowls were copied by early Kyō potters for use in the tea ceremony.

Kakiemon: a fine porcelain with decoration in overglaze enamel or underglaze blue or a combination of both, made at Arita in northern Kyūshū. Sakaida Kakiemon, the first of the noted family of potters, is believed to have mastered the Chinese technique of overglaze enameling on porcelain in the early 1640s. The ware tends to leave large areas of the fine white background bare of decoration; the designs are generally delicate and the colors clear and strong.

Kanamori Sōwa (1584–1656): Sōwa was heir to the lands of Prince Takayama in Hida Province. Disowned, he moved to Kyoto and became a tea master and designer of tea utensils. Sōwa was Ninsei's chief patron and is thought to have provided the inspiration for some of the potter's best work.

Karatsu: a type of pottery usually of heavy, rough clay, initially made in the Karatsu area in northern Kyūshū by Koreans captured during Hideyoshi's invasions of Korea in the late sixteenth century. Essentially a utilitarian ware, its simplicity and vitality made it popular in the tea ceremony. It appears in several forms, one of the best known being painted Karatsu (*e-garatsu*) with iron oxide designs.

Kobori Enshū (1579–1647): a tea master, poet, painter, and scholar who served as arbiter of taste to the shogun Ieyasu following the death of Furuta Oribe in 1615. Enshū did much to stimulate the production of tea-ceremony pottery, and seven kilns whose wares he influenced are known as "Enshū's Seven Kilns." Enshū, with Kanamori Sōwa and Furuta Oribe, was responsible for turning tea-ceremony aesthetics away from the severe, astringent taste of Sen no Rikyū.

Kōchi: the Japanese name for a type of pottery believed to be from Cochin China but probably made in the region of Canton. Imported Kōchi ware came to Japan mainly as containers for incense or medicine. The ware uses low-fired glazes to color designs carved in the clay body. It strongly influenced Oshikōji ware, the earliest Kyō pottery, and was much copied in the latter part of the Edo period.

Kutani: one of the most famous Japanese decorated porcelains, made for the Maeda clan in the vicinity of Kutani village in present-day Ishikawa Prefecture on the Japan Sea coast. The ware can either be porcelain or cruder pottery with overglaze enamels and underglaze blue in powerful designs. The Kutani kilns were active during the second half of the seventeenth century and officially closed around 1700. Although revived in the nineteenth century, the high standards set by the early ware could not be matched.

Nabeshima: one of the finest porcelains, both technically and decoratively, produced in Japan. It was made in the Arita region in northern Kyūshū expressly for the Nabeshima clan, and pieces that failed to meet their standards of perfection were destroyed. The designs, often combining underglaze blue and overglaze enamels, are conceived with vivid imagination and painted with skilled precision. The ware reached its peak of development in the early eighteenth century and gradually declined as Nabeshima support was withdrawn toward the end of the century.

Oribe: the type of pottery that derives its name from the noted tea master Furuta Oribe. It was made almost entirely for tea-ceremony use from the late Momoyama period (1568–1603) in the Mino area in present-day Gifu Prefecture. It was one of the first Japanese wares to use painted representational decoration in underglaze iron oxide. Areas covered with green copper glaze are characteristic, but the ware comes in a variety of forms. The best examples come from the late sixteenth and early seventeenth centuries and tend to be unusual in shape and color. (*See also* Furuta Oribe.)

Raku: a low-fired, soft pottery using lead glazes of subdued color. The ware was first made in Kyoto for the tea ceremony by the potter Chōjirō under the guidance of the famous tea master Sen no Rikyū. The tea bowls, generally shaped by hand rather than turned on the wheel, are related to Korean types but have a heavy, rugged quality that is unmistakably Japanese. The name Raku is derived from a seal bestowed on Chōjirō's son, Jōkei, by Hideyoshi, and it has been used by successive generations ever since. Kenzan startled his contemporaries by making brightly colored Raku bowls and also used the ware for a variety of other objects.

Sen no Rikyū (1521–91): perhaps the most famous of Japanese tea masters. He served under Nobunaga and Hideyoshi, and was particularly closely associated with the latter. Attempting to curb the extravagant and ostentatious tendencies of contemporary tea ceremony, his taste was for a rather

harshly simple and functional aesthetic. Rikyū inspired the Raku tea bowls made by the potter Chōjirō, and later by Kōetsu and others. Later tea masters and tastemakers such as Oribe, Enshū, and Sōwa directed tea-ceremony aesthetics away from Rikyū's austerity.

Seto: The Seto kilns in Owari Province near Nagoya were one of the "Six Ancient Kilns" of medieval Japan, and for centuries formed the country's largest ceramic center. During the Kamakura period (1185–1336), the first glazed pottery was produced there, inspired by Chinese celadon. Slightly later, Temmoku ware, also copied from Chinese models, was made at Seto. Civil war during the sixteenth century forced many potters north to Mino, where they produced Yellow Seto, Shino, and Oribe wares. The earliest kilns in Kyoto were probably founded by potters from Seto.

Shigaraki: a type of pottery made near Omi on Lake Biwa. Shigaraki was one of the "Six Ancient Kilns" of medieval Japan. The ware is heavy and strong, qualities required by an agricultural community. The clay body is rough and often full of impurities and fires to a light reddish-brown. The transparent ash glaze intentionally applied often has a blue-green tint. The rough and honest character of the ware appealed to tea masters. As the Kyō kilns expanded, Shigaraki potters were attracted to Kyoto, and Shigaraki clay was often used in Kyō kilns.

Shino: a type of pottery made in the Mino area of Gifu Prefecture from the latter part of the Momo-yama period (1568–1603), if not slightly earlier, and intended largely for the tea ceremony. Decoration, when it occurs, is done in iron oxide or is incised through an iron slip before being covered by the characteristic Shino off-white glaze. The best examples of Shino ware, as of Oribe ware, date from the late sixteenth and early seventeenth centuries, but in shape and decoration Shino ware is generally more conservative than Oribe.

Tamba: the kilns of Tamba, one of the "Six Ancient Kilns" of medieval Japan, are located in Hyōgo Prefecture. The body of the ware is a dark brown, often splotched with black, and a wood-ash glaze is used. Like the pottery of Bizen and Shigaraki, Tamba was a utilitarian ware that was incorporated into the tea ceremony.

Temmoku: the Japanese name for a Chinese type of pottery made chiefly in Fukien and Honan Provinces from the Sung dynasty (960–1280) onward. The glaze ranges in color from blue-black to reddish-brown and often has distinctively spotted markings. The most common shape is that of a conical tea bowl. Temmoku copies were made at Seto, and the little tea caddies with rusty brown iron-oxide glaze inspired by Chinese models were much in demand.

Tz'ŭ chou: a Chinese decorated pottery made in Hopei Province and other areas of northern China from the Sung dynasty (960–1280) until the present. Both painted and sgraffito designs were used with great imaginative freedom. Kenzan much admired the ware and copied its technique.

Index

The "weathermark" identifies this English-
language edition as having been planned,
designed, and produced at the Tokyo offices of John Weatherhill, Inc.,
in collaboration with Shibundō Publishing Company. Book
design and typography by Dana Levy. Text composed by Kenkyūsha.
Engraving and printing by Hanshichi Printing Company.
Bound at Oguchi Binderies. The type of the main text is set
in 11-pt. Bembo with hand-set Goudy Bold for display.